Photographing
the North American West

Photographing the N

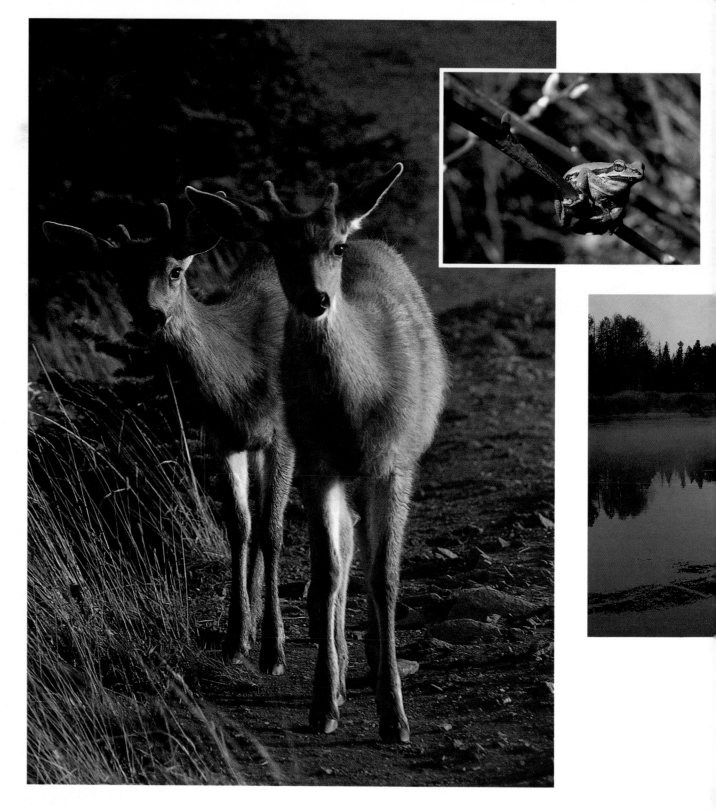

orth American West

by Erwin and Peggy Bauer

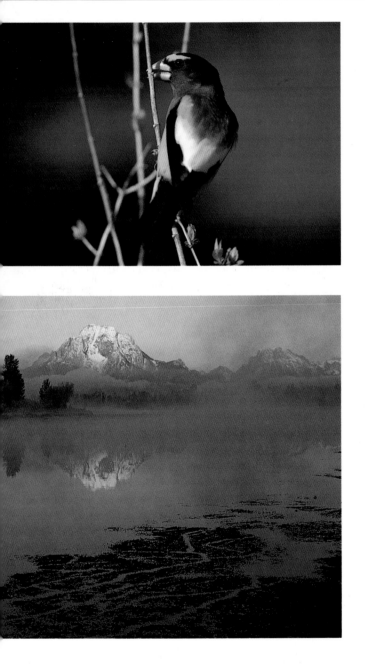

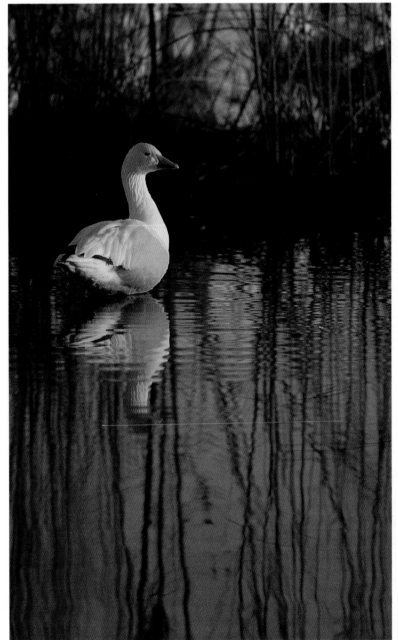

Pacific Search Press

Pacific Search Press, 222 Dexter Avenue North,
 Seattle, Washington 98107
© 1987 by Erwin and Peggy Bauer. All rights reserved
Printed in Hong Kong

Edited by Margaret Foster-Finan
Designed by Judy Petry
Composition by Scarlet Letters Ltd.

Cover: *Male elk at Beryl Spring, Yellowstone National Park. Erwin Bauer
 in the field.*

Title page: *From left to right: black-tailed deer fawns, Olympic National Park,
 Washington; Pacific tree frog, California coast; male evening grosbeak;
 Oxbow Pond and Mount Moran, Grand Teton National Park, Wyoming;
 snow goose, Klamath National Wildlife Refuge, Oregon.*

LIBRARY OF CONGRESS CATALOGING-IN-PUBLICATION DATA

Bauer, Erwin A.
 Photographing the North American West.

 Bibliography: p.
 Includes index.
 1. Travel photography—West (U.S.) 2. West
(U.S.)—Description and travel—1981-
3. Nature photography. I. Bauer, Peggy. II. Title.
TR790.B37 1987 778.9'32 87-6931
ISBN 0-931397-16-2
ISBN 0-931397-15-4 (pbk.)

Contents

1
Equipment and Techniques

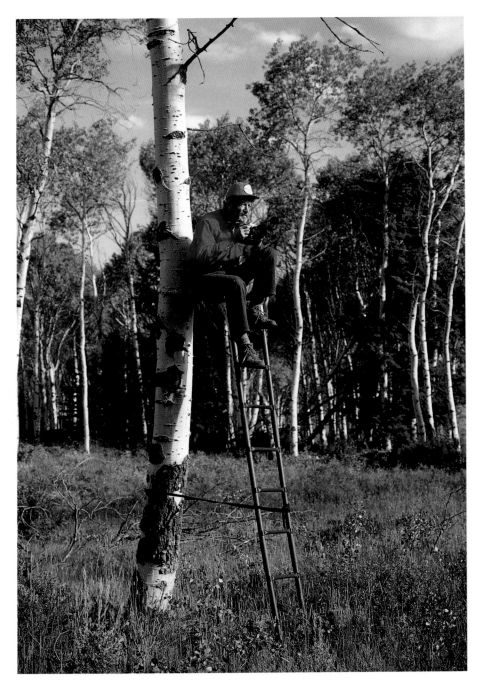

Some animals—deer especially—are less wary of a person in an elevated position than in a blind on the ground. We often use a portable ladder stand to shoot both mule and white-tailed deer.

For almost half a century we have been on assignment wandering the wild places of the world photographing its natural beauty and especially its wildlife. It has been rewarding, high adventure.

In earlier times, our equipment was crude, heavy, and not too reliable. The travel was not always easy. But that has changed. The life of a photographer is a lot more pleasant and convenient today, especially in western North America. This is a region where the atmosphere is still pure, and large accessible wilderness tracts still survive.

There is an abundance of wildlife, which is easy to see, and this is an accurate index of the good quality of human life in the region. We believe that the seacoasts and mountain ranges of the West are the most magnificent on the face of the earth. No one is ever very far from great places to take pictures.

At a seminar for aspiring photographers some years ago, Ansel Adams said that the West may be the best part of America in which to own a camera. The old master was right about that.

Almost anyone who spends much time outdoors also owns a camera and other photographic equipment. Probably that equipment is new, very sophisticated, and capable of producing quality pictures. With modern cameras and lenses, the old days of hoping that pictures will come out okay should be well behind us. And yet, far too frequently, the results do not match the potential of the equipment.

On one color slide, the majestic mountain range at sunrise, the one for which there were such great expectations, seems faded and unclear. On another slide, the deer is out of focus and is wandering away in the wrong direction. The mountain meadow of wildflowers, which seemed as colorful as a Persian carpet, is not half as brilliant in the picture as in memory. Another image is out of focus. Why? What happened?

The blame belongs as much to the photographer (and usually much more) as to his camera. Today it is possible to produce consistently good, if not actually outstanding photos, with simple and inexpensive equipment. But how? What are the rules, the guidelines, the secrets? Exactly what equipment does a serious nature photographer need to shoot in the West?

THE OUTDOOR CAMERA

A camera for outdoor, adventure purposes should be convenient to carry anytime and anywhere, and it should not be too heavy or too bulky. It should be sturdy, reliable, fast to use, and able to withstand a fair amount of rough handling and abuse. This camera should function in extreme cold as well as in hot or damp weather. Any camera that is used frequently should sit comfortably in your hands. These specifications translate into just one camera: the versatile 35mm single-lens reflex camera (hereafter 35SLR). All of the photographs in this book were made with 35SLRs.

With a single-lens reflex camera the photographer sees his subject

through the same single lens that transmits the image to the film. This is done with a pentaprism and mirror. The image coming through the lens is deflected by the mirror into the prism, right side up, to the viewfinder and the photographer's eye. Pressing the shutter release flips the mirror out of the way, and the image is projected directly through the opened shutter to the film.

Keep in mind, however, that not all serious nature photographers prefer 35SLRs. Some, notably those who specialize in landscapes and still lifes, carry large-format equipment. Large format in this case means any camera system that uses film larger than 35mm, from 120 film size (2¼″ × 2¼″) to the studio-type cameras that use sheet (rather than roll) film. But the larger and the heavier the gear, the less it suits an active photographer who sometimes departs far from the beaten tracks. Large-format cameras also are at a distinct disadvantage for shooting action and wildlife because they are slower to operate. However, most of the information in this book should be helpful no matter what format camera you use.

There are a bewildering number and variety of 35SLRs on the market. Most of them are marvels of technology. Selecting the best 35SLR may seem impossible, but the truth is that all of the well-known brand names— Nikon, Canon, Olympus, Pentax, Vivitar, Minolta—are equally well designed, efficient, reliable, and part of a complete photo system. Each system consists of many interchangeable lenses, from wide angle to long telephoto, plus many other accessories designed to fit that system's cameras.

The great advantage of any SLR camera is that the subject is viewed and focused directly through the lens. You capture on film exactly what you see in the viewfinder the instant you expose the picture. Most 35SLRs also have a focal plane shutter at the rear of the camera, with the top shutter speed of 1/1000 second. A focus plane shutter (usually two flexible curtains that travel in the same direction) is one built into the camera body just in front of the film. As this is written a number of cameras offer 1/2000 second shutter speeds, and one has a 1/4000 second shutter speed. These are far faster than an average photographer ever needs, but might occasionally be helpful to a photographer shooting wildlife while using very fast film.

The choice in 35SLRs is between standard versus extremely compact, lightweight models and manual versus automatic operation. The main advantage of the lightweights becomes obvious when you are already carrying a heavy load. The disadvantage comes in trying to hold them absolutely steady. Some of the superlights are so fragile that they must be handled with greater care than is always possible. Automatic operation is worthwhile, too, because fine pictures result from the minimized concentration. But our own preference is for the so-called standard sized 35SLR with an accurate, built-in exposure meter and the option to not use the meter at all.

One factor much more important than total automation or size is never having to look away from the viewfinder to make camera settings and adjustments. All the information you need to know (aperture and shutter speed for correct exposure) should be visible right there beside the picture you see in the viewfinder. After familiarizing yourself with the 35SLR, you should be able to focus and shoot without fumbling, looking up, or giving the matter any thought whatsoever. Your camera design should free you to concentrate totally on your subject. This is critical when the subject is a wild creature.

The newest feature being built into 35SLR systems is autofocusing, which also can improve wildlife and action photography by freezing moving subjects in sharper focus than is possible manually. When the shutter

release button is depressed partway, an invisible beam of infrared light bounces off the subject in the center of the viewfinder. This activates a tiny motor that instantly focuses the lens on that distance. Most autofocus 35SLRs also have an autofocus lock. Using this you can focus on a subject, lock the focus, then reaim the camera so that the subject is where it will look best, perhaps somewhat off-center. But be aware that when the action is fleeting, it takes almost as much time to do all this as to focus manually.

Modern 35SLRs are complex mechanisms. Our aim, however, is not to go into detail about the mechanism, but to suggest how anyone can use whatever equipment is already available (or soon to be acquired) for the best photographs of the North American West, and therefore for the greatest satisfaction. Myriad fine technical texts and instruction books are already available, the most valuable of all being the specifications and service manuals that come with every major item of photographic equipment. Always read these manuals carefully.

Of course, it is vital to know and understand your own camera thoroughly. But excessive knowledge of photographic equipment is not everything, and in fact, it can be a roadblock to creativity. The best auto mechanics are not necessarily the safest drivers and, similarly, a good many photographers know all about cameras except how to take good pictures. This book is dedicated to those who simply want to take good (or better) photographs.

LENSES FOR OUTDOOR PHOTOGRAPHY

The most important part of any camera is the lens affixed to it. Only the photographer's own technique and composition have as much effect on the quality of a finished picture as the capability of the lens. The lens is what projects the subject you see through the viewfinder onto the film. Lenses make or break pictures. To be able to shoot everything in the West from flower or insect close-ups to big game animals and landscapes, a photographer needs more than one lens. He needs a variety of lenses that have different focal lengths.

Buying a lens can pose some risks, because in the shop there is no easy way to distinguish between a good one and a poor one, optically. Most lenses produced by major manufacturers are good. It is reasonable to assume that the best ones cost the most. But still, the difference between an inexpensive and an expensive lens of the same advertised capability may be practically indistinguishable outside a testing laboratory. So you must depend either on the advice of serious photographers about equipment quality or on your own instinct.

The lens sold with most 35SLRs has a focal length of 50mm. This is considered the normal lens for a 35mm camera, because its perspective is most nearly like that of the human eye. We use this lens least often. And when wandering far afield, feeling every extra ounce of weight, we do not even carry the 50mm. It is a good idea when selecting a 35SLR to buy the camera box or body alone, without a lens. Then purchase separately the lens you genuinely need.

Our dependence on zoom lenses is extremely high because many of those manufactured by major 35SLR companies are as sharp (in our opinion) as the single-focal length lenses they manufacture.

A single zoom lens can give an instant choice of focal lengths, from wide angle through normal to telephoto, all in one tube. A single zoom lens can offer the same variety as carrying three or four separate lenses. For example, the two zooms that we frequently carry (a Nikkor 35–80mm and a Nikkor 80–200mm) give us a very wide range for their total weight and bulk. For a long time the 80–200mm (or its equivalent) has been our most important and most frequently used lens. We also depend heavily on a Nikkor 200–400mm for shooting wary wildlife that is farther away.

We do not use a wide-angle lens as much as some other photographers. These are used to shoot certain scenes of sometimes steep landscapes, which are very near to the photographer, or to shoot panoramas. The short focal length of a wide-angle lens allows you to photograph a subject that you cannot back away from. The depth of field of these lenses is greater. You can shoot everything from the immediate foreground to infinity in sharp focus. But wide-angle lenses also can be deceptive. Unless you are very careful you may distort the subject and make a scene seem much farther away than intended. Wide-angle lenses also tempt you to include too much area in one picture, thus ruining the composition.

We use telephoto lenses for 90 percent or more of our work, short or medium focal length telephotos for landscapes, and long ones for wildlife.

Telephotos are lenses with longer than normal focal length (the distance from the front of the lens to the film). They magnify the subject while transmitting it onto the film. If you have a telephoto lens on your camera, a deer or any subject will appear larger in your picture than if you are using the so-called normal 50mm lens that sees a subject as the naked eye would see it. If your telephoto is 100mm, the image of the deer in the viewfinder will be twice as large as with a 50mm lens. If it is a 200mm telephoto lens,

A long telephoto lens makes it possible to shoot large animals safely and from a distance. Peggy Bauer is photographing a mule deer buck slashing at brush during the autumn rutting season. It is wise not to press animals closely during this period.

the image will be four times as large, and so on. Because you do not have to approach a wild creature as close *with* a telephoto lens as *without* one, the modern telephoto lens is what makes modern wildlife photography possible for everyone.

Telephoto lenses do have drawbacks. One drawback is that the longer they are, the slower they tend to be. All lenses are often described as being either slow or fast. In this case relative speed means the ability of a lens to collect and transmit light rays. A photographer can use a fast lens in poorer daylight and/or with a faster shutter speed than he can a slow one. Thus a telephoto lens with a fast f2.8 or f3.5 lens is generally more desirable than a slow f8 or f11 lens. Although the major 35SLR manufacturers are now producing faster (but quite heavy and expensive) telephoto lenses with long focal lengths, telephotos still tend to be slower than shorter lenses and therefore more restricted to shooting in bright light.

The longer the telephoto, the more the slightest camera movement is exaggerated. You have to use some sort of firm base or support, as opposed to hand holding the camera, when using a telephoto lens of say 300mm and longer. Subject movement is more difficult to arrest than with a short lens, and thus you need to compensate with a faster shutter speed to avoid blurring.

Telephoto lenses should be purchased with care, especially if you plan to shoot wildlife. The natural inclination is to buy the longest lens you can afford. However, an inexperienced photographer should begin with a 200mm lens or an 80–200mm zoom. If completely satisfied with the results, especially with the sharpness and ease of handling, it is time to graduate to something longer and more difficult to use.

For shy and elusive wildlife, we depend on two lenses: a 300mm f/2.8 and a 400mm f/3.5 telephoto. Since we both carry identical 35SLR camera bodies, we can exchange these two as well as all of our other lenses. We also carry 1.4X and 2X lens extenders (also called teleconverters), which in a pinch, can be inserted between camera and telephoto lens to increase the focal length. A 1.4X extender changes a 200mm lens to a 280mm lens (1.4 times 200 = 280) and a 2X extender converts a 200mm lens to a 400mm lens (2 times 200 = 400). Extenders are small enough to fit into a breast pocket, but we only resort to their use when it is impossible to get closer to a subject. There is a penalty for using extenders: the 2X means the loss of two f/stops in the exposure, and at times there is not enough light available to permit this loss.

For close-ups (but also for some scenics), we always carry and regularly use a macro lens. Designed especially for closeup photography but capable of serving as a normal lens, a macro or micro lens permits close lens-to-subject focusing without accessory equipment. You can use a macro only inches from a subject or to shoot distant scenes. It is impossible to do a good job of wildflower, insect, or lichen photography without it. A macro of about 55mm is the one we find best for wildflowers, but 100mm or 135mm macros probably are better for insects and perhaps some reptiles and amphibians, because you do not have to get as close to the subject. Good close-ups also can be made by using the lens attachments or extension tubes that are part of complete 35SLR systems.

Admittedly it may seem just an unnecessary expense, but we also always carry (or at least keep accessible) a spare camera body exactly like those we use. The more a person shoots, the more a spare is likely to come in handy and suddenly be worth its cost and the increase in weight to be carried. Also it is easier and faster to pick up a second loaded camera than

to reload film while something important is taking place.

Most nature photographers overwhelmingly prefer color film over black and white, which is easy to understand. There is a fairly good selection of color film on the market. You must choose between slide (positive film) and print (negative film). Manufacturers generally use the suffix "chrome" to label their slide film (Kodachrome, Agfachrome, Fujichrome). They use the suffix "color" to indicate print film (Ektacolor, Fujicolor). Buy slide film if you want transparencies that can be projected onto a screen or if you ever expect to sell your work for publication. Use print film if you would rather end up with prints for an album.

We use and strongly recommend slide film. The individual print you receive from one exposure of print film is certainly cheaper than having a print made from a color slide (which also can be done). But it costs less to have a roll of slide film processed than it does to have a small print made of every exposure on a color print roll. In the long run it is far cheaper and more satisfying to use slide film and invest in a slide projector.

Both slide and print films come in a variety of speeds from ASA/ISO 25 (the slowest) to ASA/ISO 1000 (the fastest commercially available nowadays). ASA/ISO is the current international rating standard for film speeds. Every box of film bears its film-speed rating. Any film's speed indicates its sensitivity to light. Slow speeds react slowly to light and so are best when there is plenty of it, as on a bright day. Fast film reacts more quickly to light and can be used where there is less light, as on dreary days or in dense shade. ASA/ISO 64 film is a little more than twice as fast as ASA/ISO 25 film. In comparison, ASA/ISO 100 is almost twice as fast as ASA/ISO 64.

In practice, doubling film speed (as from 25 to 64, or 64 to 100) gains you one f/stop on your camera setting. Films with speeds rated from 64 to 125 are considered in the medium-speed category. Any rating below 64 is considered slow and above 125 is fast. Any film rated at 1000 is fast enough to shoot virtually anything outdoors from just after daybreak until near dusk.

Most professional outdoor photographers choose a slow film because it is sharper, has a finer grain, and offers better contrast than faster film. But its relative insensitivity (slowness) to light makes it less flexible to use. A photographer does not have the wide option of f/stops and shutter speeds when loaded with slow film. Faster film is more forgiving, especially in low levels of light, but it has a coarser grain and provides less contrast. Many professional photographers do not like the "cold" or the bluish color of fast films.

The correct consensus among most serious outdoor photographers is that, day in and day out, Kodachrome 64 is the most color-accurate film. The color matches closely the natural bright color of the subjects photographed. Too often faster films tend to turn out on the dull side. Kodachrome 64 is also sold in a Professional Kodachrome 64 grade, but the only difference we could ever detect between the two was the greatly increased price of the latter. A Kodachrome 200 was introduced late in 1986, but photographers will need considerable time to evaluate it. Fujichrome 100 has become more and more popular with those who make a living at photography.

There are numerous advantages to selecting one type of film and then using that exclusively. Of course it is a good idea to first test all different kinds under different conditions. But after that, you can be assured of consistently good results by sticking with a film you understand. Far from the

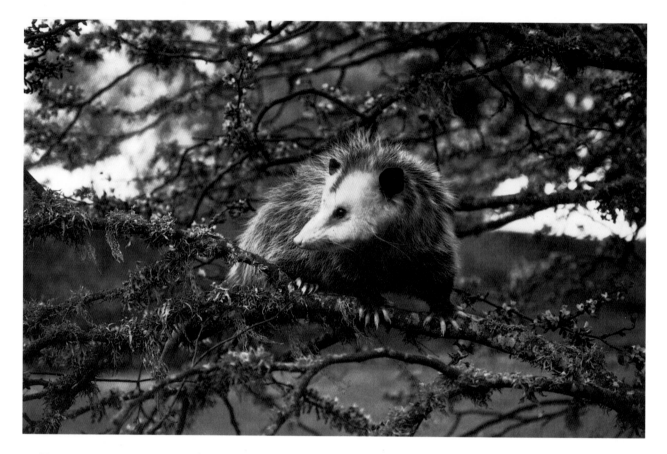

For at least nine situations out of ten, the best film for shooting the wild West is of slow to medium speed with fine grain. The opossum in a blossoming redbud tree was shot with Kodachrome 64, which averages best for all outdoor use.

least advantage of using one film is that you can forget about resetting the camera's film speed each time you change film. Failure to reprogram the camera for the new film speed can result in the tragedy of roll after roll of poorly exposed and useless photographs.

Curious as it may seem, when using Kodachrome 64, we keep our film-speed dials set at 80 or 100 instead of 64. This gives us a slight under-exposure and a deeper, more pleasing color saturation. But before you also do this, test a roll of film to see which meter setting best suits your own taste.

Some pictures—rather some films—may benefit from filters, which may enhance the color or mood. A thin orange filter, for example, will block out all but warm colors of the spectrum and turn a normal sunset into a spectacular one. Polarizing filters darken sky tones and are used to reduce glare and reflection. Skylight filters are used a lot, with little effect except to protect the lens glass when you are not using a lens cap.

We have been photographing nature for a long time and some of the transparencies in our files are up to forty years old. It is worth noting that the Kodachrome slides have retained their color best of all. Ektachrome and Agfachrome slides, which we also have used from time to time, have faded badly with age. That word to the wise photographer ought to be sufficient.

Some other film tips: it is cheaper to buy film in quantity, especially if you are quite active, and then store it in a cool, dry place. You can keep it in a refrigerator, vapor-sealed against moisture inside its original cartridge. Long exposure to heat and sun can be damaging. We carry more film than we are ever likely to use and more than once that foresight has been justi-fied, especially on long trips far from home. Expensive as it is, our film bill

still amounts to only a fraction of what any adventure costs. We figure there are better places to skimp.

OUTDOOR PHOTOGRAPHY ACCESSORIES

The first thing to do after buying a new 35SLR is to throw away any carrying strap or leather carrying case that comes with it. Most of these are next to useless. Replace the standard strap with a new wide one of rough, two-inch-wide webbing material. This is less likely to slide off your shoulder or to cut into your neck as a thin strap will. When carrying a camera as you should, ready to use and uncovered around your neck, adjust the web strap so that the camera rides high on your chest instead of bouncing around at your waist. For field use, as when climbing in rugged back-country, consider using a camera harness instead of the shoulder strap. A harness holds the camera (or even two at once) snug against the chest by means of straps crossed over the shoulders and around the back. The camera can be released quickly and then replaced in the harness, leaving both hands free.

We have equipped all of our 35SLRs with motor drives. (Many come with motor drives built in as part of the unit.) These can be a disadvantage in that (with batteries included) they are heavy, and the delicate mechanism may fail at a critical moment. The characteristic noise may also frighten some nervous creatures. But all of these drawbacks are clearly outweighed by major benefits.

To begin, a motor drive makes following any action—a running deer or a flying goose—much easier. But most important, a motor drive lets you concentrate on what you see in the viewfinder. You eliminate the considerable distraction of manually advancing the film after each exposure. Just this small distraction can cause a photographer to lose precious pictures. A motor drive also can quickly rewind film, but unless in an extreme hurry, we rewind by hand to save the drain on the batteries.

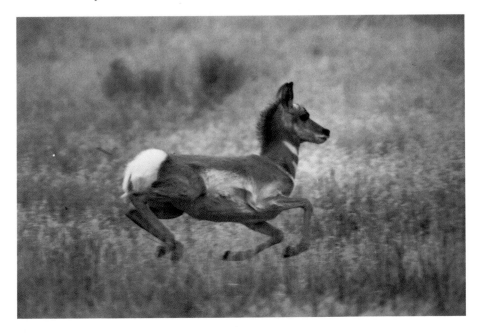

Running Oregon antelope and other action pictures are best shot with a fast-to-operate 35SLR held in the hands. A motor drive makes it easier to follow the action without having to advance the film manually. More exposures of a running sequence are also possible.

A lens shade, which protects the lens from the direct rays of the sun when shooting, is a wise investment. This protection, especially in brilliant light, improves the general clarity and quality of all photos. But a lens shade is also easy to misplace or dislodge. It is best to somehow keep it attached to the camera or the lens.

📷 EXPOSURE

The through the lens (TTL) exposure meter designed into most 35SLR bodies is accurate enough for most outdoor photography. We choose to set our cameras on manual operation, using the built-in meter only as a rough exposure guide. Whenever possible, or whenever we are in doubt about a very important picture, we bracket exposures to be certain that we connect with the perfect one. By bracket we mean to shoot the same picture at either one or one-half stop above and below the exposure recommended by the camera meter. Sometimes less than perfect exposures make the most dramatic pictures.

A separate (from the camera) exposure meter is only an extra item to be carried and possibly misplaced or dropped. Nonetheless the spot exposure meter is a valuable accessory for precision work if you do not have to carry it far, as an extra item in a backpack. Any spot meter gives an accurate reading on a very small area, say on the flank of an elk standing in the shade. Ours is especially useful when shooting from a blind or fixed position where there is enough time to put the camera aside and use it. But these meters are very delicate and must be handled carefully. We often carry ours in a belt holster similar in shape to a pistol holster.

For those emergencies, when exposure meters are not working, keep the "16 method" exposure solution in mind. When photographing outdoors on perfectly clear days, with the sun behind you, the proper exposure will always include a shutter speed that closely matches the ASA/ISO speed of your film. It works as follows:

First set the lens opening at f/16. If the ASA/ISO film speed is 64, set the shutter at 1/60 or 1/75 (whichever of the two figures is on your shutter dial), which is the closest setting to 64, and shoot. If the ASA/ISO is 100, set the shutter at 1/100, and so on. Of course you may have to make some adjustments for changing light conditions, such as closing the shutter from f/16 to f/22 in brilliant light over sand or snow. Or you may have to open it from f/16 to f/11 when thin clouds cover the sun.

Improper exposure (together with less-than-sharp focus) is the most common cause of photographic failure and disappointment. Some exposure problems can be traced to built-in camera meters that are incorrectly calibrated. Many are shipped from the factories in Japan already set to slightly overexpose pictures (overexposure gives paler, more washed out color), probably because manufacturers have concluded that most users will be shooting color print film. So it may be necessary to either have your exposure meter recalibrated or to always set the meter at a higher ASA/ISO speed.

It is important to test your camera (particularly a new one) before any major trip or photo expedition. Otherwise, you may be horrified with the results of your photographic endeavors. With fresh batteries in the meter run a twenty-exposure roll (otherwise we recommend thirty-six-exposure

rolls for both economy and efficiency) through the camera on a variety of scenes and subjects. That is the only way to assure that your meter is working properly.

To keep camera gear in working order in the field, it is sensible to carry along a few cleaning and repair items. A set of jeweler's screwdrivers or a pocketknife with multiple tools can take care of minor adjustments. Do not tamper with any optical glass and clean these sensitive areas only with soft brushes, lens cleaner, and optical cloth. Any glass in any good camera or lens is soft and therefore highly susceptible to scratching.

CAMERA SUPPORTS

No better advice can be offered to an outdoor photographer than to use some kind of support when shooting. That may simply mean sitting down on the ground and using your bent knee as a fairly firm rest. It also can include resting the camera on the roof of a car, against a tree trunk, or over a boulder as you aim, focus, and squeeze the shutter. Any of these devices or techniques is better than standing erect and just holding the camera in the hands at eye level.

Incidentally, there is one proper way to hold a camera. Grasp the camera, or lens if it is a telephoto, in the palm of the left hand, palm up. In this position, you use the thumb and fingers of the same (left) hand to focus. The right hand grips the camera body and steadies it. The right forefinger rests lightly on the shutter release. Holding the unit this way is comfortable.

Nothing matches a firm, adjustable-to-even terrain tripod when shooting animals or scenes with a telephoto lens. But no tripod is any better than its tripod head to which the camera and lens are affixed. We prefer Monoball heads to all the others we have tried.

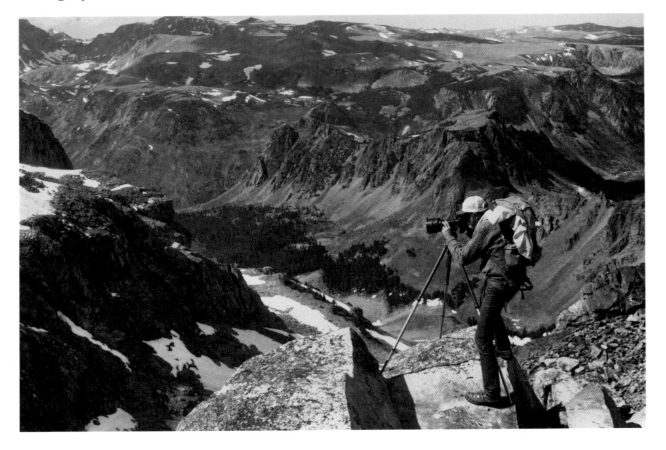

By shifting your body to adjust, you can easily follow a moving target. We consider this the best of all ways or postures to shoot fast action.

Some top professional photographers use their 35SLRs attached to shoulder devices roughly similar to rifle stocks for wildlife photography. They hold the unit as they would hold a gun and trip the shutter by pulling a trigger. Photographers, especially those who design and build camera stocks to fit their own physiques and special needs, achieve excellent results, particularly of flying birds. For our own purposes, we have not yet found a stock that works as well as merely holding the camera or mounting it on a tripod or monopod.

It is not a bad idea to use a monopod with any telephoto lens shorter than 300mm. A lightweight, tubular monopod, which telescopes from about sixty inches extended down to twenty inches, can be carried afield in the hand, in a photo vest pocket, or suspended from a backpack loop. In a pinch we have used a monopod as a walking stick on rough terrain, as a wading staff to cross a swift creek, and even as one of a pair of ski poles.

However, there is no substitute for a tripod when shooting from a blind or fairly static situation. The main trouble is that firm, supportive tripods are heavy and bulky, and they restrict maneuverability. When shooting wildlife, you can too easily miss a one-in-a-million shot while moving or adjusting a tripod. But the pictures you do get are likely to be a lot better than would result from failing to use the support. So it is a matter of compromise and personal preference.

Not many tripods or tripod heads are more than just adequate for active outdoor photographers. When fully extended, the light ones are not sturdy enough to hold a motor-driven camera with a long, heavy telephoto lens. And few of the heads presently available are suitable for smoothly tracking a rapidly moving creature. Our solution has been to settle for a too heavy, but honestly sturdy tripod with legs that adjust to stand solidly on any sloping or uneven terrain. (Beware of tripods that have legs that are not individually adjustable to uneven ground.) Unfortunately this choice of ours is not a joy to carry far, which we must often do.

Be extremely selective when buying a tripod head. It is the vital link between your camera and its support. Test them out in the shop and (if possible) in the field before buying one. After testing many, we now use the expensive and heavy Swiss-made Monoball with quick-release mounting (of camera and telephoto lens). Such a good tripod head holds a camera exactly where you point it. It allows shooting absolutely sharp pictures even while you follow the action. Ideally, panning left or right and up or down should be so fluid that you can concentrate totally on composition and focus.

CARRYING CAMERAS IN THE FIELD

Any outdoor photographer faces the dilemma of how best to carry gear and other nonphoto items in the field. There are three choices, depending on how far afield you plan to go and for how long.

The simplest, and in many ways the handiest, carrier is a belt or fanny pack. These fit snugly around the waist and can accommodate a limited amount of film and accessories. Belt packs are fine for short hikes when you are out to film scenes and wildflowers and do not need long telephoto lenses for wildlife.

A photo vest or jacket is as convenient as a belt pack, but it handles much more gear in separate compartments that are easily accessible. One vest, designed by Leonard Lee Rue III, is made of camouflage cloth, has a ventilated back and drop seat (for plunking down on cold, wet ground), nineteen separate pockets, room to carry several lenses, a tripod, and shoulder loops for an extra camera. It is a rare, good item produced with mobile outdoor photographers in mind.

For going into the backcountry for a day or several days, a backpack is the obvious answer. Our favorite for a long time has been a medium-weight, exterior frame model with many compartments. It is roomy enough to hold all the camera gear we are likely to need for an extended period. And with two backpacks, we can carry the freeze-dried food, extra socks, rain gear, a two-person tent, and sleeping bags. Our backpacking gear is as important as our optics for reaching super photographs.

In case of foul weather, we always carry individual zip-lock plastic bags for cameras and lenses. Those same sealed bags are also dust protectors. Also there are plastic rain covers, which shield a 35SLR and telephoto lens up to 200mm and can be carried and folded flat in a pocket. A photographer can make his own rain cover out of clear plastic for use with longer telephotos.

For traveling from place to place by car, our camera equipment rides in Halliburton aluminum or Pelican plastic cases that are waterproof and dustproof and can be locked. The individual pieces are cushioned on foam inside the cases. For packtrips—riding on horseback into wilderness areas—we have made our own roomy, padded, leather saddlebags with separate compartments for lenses, film, and other accessories. The lenses are also cushioned against the rough ride.

BLINDS

In many parks and sanctuaries of the West, wildlife can be approached within reasonable camera range simply by being cautious. The animals in larger national parks are often accustomed to people and do not mind having long lenses aimed at them. But other birds and mammals may be warier, and eventually it becomes necessary to use some sort of blind.

A blind or hide can be anything from a sheet of camouflage cloth draped over the human body or a cardboard refrigerator packing crate to some permanent structure built around wood or metal framing. We have used our own living room as a blind for the creatures visiting the back porch feeder. And we have shot many fine wildlife photographs when using our car as a moveable blind. Incidentally, some wildlife is much less fearful of a motor vehicle (or a person in a motor vehicle) than of the same person on foot.

We have fashioned temporary blinds by weaving natural grasses and vegetation into a section of chicken wire supported by four corner rods. We have used driftwood to build hasty blinds on beaches from Oregon to Alaska. In places where collecting natural material is not permitted, we substitute an old sheet of tattered canvas or a sheet of camouflage cloth for the chicken wire and grass. Most of the time, the location of the blind and its rigidity are much more important than the material that goes into it. A blind must be taut so that it does not flap or snap in the wind and panic wild-

This one-person blind can be set up almost anywhere in a minute or less. It is light enough to be carried over a shoulder to distant sites. Eventually a blind becomes a necessity to every serious wildlife photographer.

life nearby. For use in the rainy Northwest, it should also be waterproof. A blind must be roomy and comfortable enough that a photographer can spend long periods inside without fidgeting or cramping. There may even be times when the photographer will want to sleep overnight right in his blind to be on the spot at daybreak.

Probably the best multipurpose blinds are those being manufactured commercially, specifically for that purpose. Leonard Lee Rue III markets a dome-shaped, camouflage model (Ultimate Blind), which can be set up almost anywhere in twenty seconds. Eureka! Tents manufactures a fine, quick-to-erect blind with three levels of zippered camera openings on all sides. A person can squat, sit erect, or stand up inside this one to get different camera angles. It is also possible to convert many of today's small tents or ice fishing shanties into portable blinds to meet certain situations. A blind might even be mounted in a small rowboat or skiff or on a truck tire tube for floating/filming over shallow water. You wade and stand inside the tube.

Sometimes only elevation or an elevated blind is all that is necessary to be above a scene and above the suspicions of some wildlife. The Baker Company of Valdosta, Georgia, sells tree blinds, portable ladders (to climb trees), and climbing platforms. There is immense excitement and fascination in shooting from blinds. Once the wild residents of the area become used to it, they show little concern and may venture near. Even when not taking pictures, it is possible to study many creatures and their natural behavior from blinds.

Depending on your personality, photographing from a blind can be fascinating or boring. You have patience to sit and wait, or you have not. Every year extraordinary pictures of wildlife antics and behavior are taken

by people crouched behind camouflaged canvases. But equally great pictures are taken by more restless ones hiking on woodland trails with eyes wide open.

The truth is that some wildlife is simply not approachable in broad daylight. You resort to a blind—or else. Beavers, for example, have always eluded us, even though we live where they are abundant. We had not been able to shoot beavers that share the same area with moose, marmots, and mallards. A portable blind was our answer.

A pair of beavers built a dam across a meadow stream and as water was impounded, built a lodge for the winter. Although it was difficult to see the shy beavers even from a distance, they paid little attention to our quickly erected portable blind, which was staked out first near the dam and later near the lodge. Nor did they mind having our blind in one place one day, and in another the next. The sight of a human being was obviously what frightened them. Before we finished filming, a beaver once sat preening in sunlight only ten feet away.

A collapsible blind, which can be carried in a backpack or slung over a shoulder, is an immense boon to a wildlife photographer. Many of the elusive creatures remain too distant from a permanent blind for photography. A distinct advantage of the portable is the margin for error. If you pitch it in the wrong place to start, you can easily move it to take advantage of the subject's location, behavior, or the available light.

For nervous creatures, locate a portable blind far away at first. Then slowly, daily perhaps, inch it a little nearer. If a subject we want to film still seems suspicious of our blind, we use an old trick. Two of us walk close together to the blind. One gets inside and sets up the camera and when that is done, the other walks away. Birds and mammals cannot count. Or at least the person walking away seems to allay fears.

Another strategy is to leave a portable blind in a general area and, although unused, shift it from spot to spot over a period of time. This is possible if you happen to be shooting near your home. The theory is that wildlife in that area soon regard the portable blind as just another natural object in the scene. When you finally move it to the spot where you will be filming, the subject will be familiar with the blind.

Portable blinds of camouflage cloth are better than those of plain or even brightly colored cloth (as a backpack tent converted to a blind). Color probably makes little difference to wildlife, but camouflage is less visible to curious people who just have to see what is inside. Theft of blinds has also become a headache in some areas.

◉ WILDLIFE CALLS

Many animals can be coaxed into at least fair photographic range with a wildlife call. A few birds and animals can be tempted almost into the caller's lap. Of course, it is a skill that requires practice and in the beginning, some patience.

Many of the predators, especially foxes, coyotes, and bobcats, cannot resist investigating the agonizing squall of a smaller animal in trouble. Although we have not been successful with larger predators, Murry Burnham, a designer and manufacturer of wildlife calls, has called black bears, wolves, and cougars into the range of a long telephoto lens. He believes that

eventually he could reach all of these with regularity. It probably is a matter of experimenting with different kinds of attractive sounds.

For a long time hunters have been attracting deer into gunning range by rattling a pair of discarded deer antlers together and by scraping the antlers on hard ground and against brittle bushes. During the autumn rut, male whitetails often clash with other bucks and behave in this noisy manner. When a buck hears other bucks (or someone imitating them), he quickly comes to investigate. We have had rutting whitetails rush up (some suspiciously, but others totally without caution) to within fifteen feet of where we rattled antlers. In fact we have shot many cover photos of white-tailed deer with this ruse.

In varying degrees all antlered animals, but especially mule deer and elk, will also seek out the sound of rattling antlers. For centuries Indians have called moose in the fall by grunting either by mouth or amplified through a rolled up birchbark shaped like a megaphone. Even better than rattling for bull elk during the early autumn breeding season is using a mouth call made from a plastic tube or section of garden hose to imitate the strange and penetrating bugling of a herd bull with a harem of cows. This artificial elk challenge has enticed many a trophy bull into the viewfinders of our cameras.

All waterfowl, especially the young ones recently arrived on migrations from the Arctic, can be tempted to fly and perhaps land near a photo blind. But calling ducks and geese works best if the caller also spreads a set of lifelike decoys near the blind. Many songbirds can be called with one of the small, pocket-sized friction squeakers sold by the National Audubon Society and Sierra Club. At night some owls and hawks will answer the same squealing messages broadcast across the darkness for coyotes and foxes. Especially during the spring gobbling season, turkeys will answer calls made with a variety of devices from turkey bones scraped on hollow cedar boxes to rubber diaphragms clucked in the mouth.

Recently, we experimented with taped calls played on tape recorders with amplifiers. This increases the effective range of any call, and the taped sound of a live animal may be more convincing than our own vocal imitations. Although many creatures may not actually dart into camera range at the sound of a call, they may at least expose themselves and thereby betray their presence. More than once that has been most helpful.

◉ COMFORT IN THE BACKCOUNTRY

Any determined photographer in the West must depend on other equipment, which is just as important as his camera and lenses. Footwear, for example, is critical. With few exceptions, we have too seldom been able to shoot top quality pictures of elusive wildlife without walking (often for long distances), wading streams, climbing on rough trails, or struggling over muskeg. A wildlife photographer needs a variety of footgear, especially sturdy, ankle-high boots with lug soles. These should fit perfectly, be completely broken in, and waterproof. For winter wear, insulation is a great help. We have often worn gaiters in combination with our hiking boots when filming in deep powdery snow.

A thoroughly outfitted photographer will also carry in his vehicle a pair of rubber hip boots and/or chest-high waders to travel through and around

wetlands and when foul weather arises. These also should fit perfectly over one or two pairs of soft, but heavy woolen socks. Knee-high trapper's or irrigation boots are lighter than others, but limit the depth of water a person can traverse. For wet weather we also wear tough plastic ponchos that will not rip in the brush. We carry cameras under these. It is also possible to shoot while standing inside a large, inverted plastic garbage bag with an opening cut for the lens. Umbrellas can be clamped onto tripods above cameras.

Since wildlife photography means vigorous hiking alternating with being stationary for prolonged periods, we use the layering system of dressing. That is, we wear or carry layers of light clothing rather than a single heavy garment. That way we can add or remove as our activity and the temperature dictates.

Carrying layers of extra clothing, along with extra lenses, film, and high-energy snacks, requires a roomy backpack, rather than just a daypack. How many layers you tote depends upon the elevation and the season. During late autumn we depend on four layers to withstand the intense cold and whistling wind. On the inside we wear polypropylene underwear, then woolen pants and shirts, a sweater, and a waterproof Thinsulate parka. Of all the insulating materials we have worn, Thinsulate garments seems to keep us the warmest for their weight.

Any photographer can far better concentrate on his shooting if he is warm and comfortable on bitter days.

2
Portfolio of the West

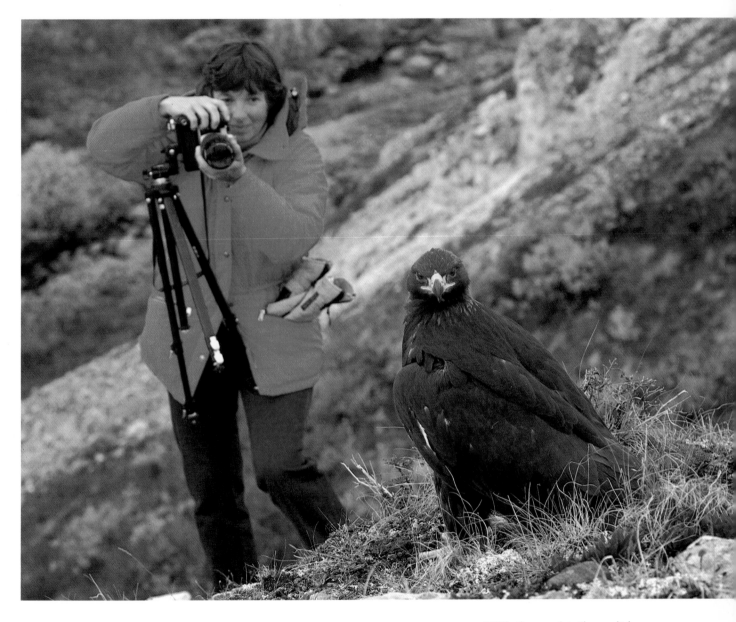

With time and patience, it is possible to approach wary creatures. We watched the golden eagle gorge on a caribou carcass until it could not take off. Then we moved in for a few exposures.

PRACTICE ON THE HOMEFRONT

In outdoor photography there is no substitute for practice to achieve smashing outdoor pictures day after day. The more you shoot and handle a camera (even an empty camera), the more proficient you become. Practice is important for testing new lenses and exposure meters and for comparing different types of film.

All over the West, complete wildlife communities live just outside the back door. Ruffed grouse make tracks over our winter woodpile, which in the summer is a haven for chipmunks and red squirrels. Moose and coyotes are regular visitors. Such birds as Steller's jays, evening grosbeaks, hairy woodpeckers, and finches freeload on the suet, millet, and sunflower seeds available in our back porch feeders.

It is possible to photograph wild creatures around your property without feeding them, but grain or other enticements placed in regular feeding stations make it a lot easier. There are three best times to feed and photograph: during nesting, when migrant species first arrive from spending winter farther south, and in winter for those birds that are not migratory.

We place feed where the birds can find it, yet where the offering is hidden from our camera's view. Rather than simply wiring large chunks of beef or venison suet in any old place, we drill holes in sections of tree trunk and stuff these with the suet. When a woodpecker finds it, we are ready to film the visitor perched in a natural feeding posture.

We do not use trays or commercial-type bird feeders. Instead we gouge out crevices in dead tree branches and place seeds there, or we hide them behind other natural objects. Our natural feeders attract chipmunks and squirrels as well as birds. They are lively and interesting photo subjects. Many species take sunflower seeds (which are the most expensive) more than anything else. But millet, sorghum, or kaffir corn are equally acceptable. Peanuts, cracked corn, peanut butter, and some kinds of pellet dog food work very well. We use peanut butter, an excellent multipurpose lure, to draw small creatures to attractive spots, because it can be smeared or inserted into tiny niches exactly where you want it. Squirrels and birds cannot quickly carry peanut butter away.

A minihabitat or rocks, plants, and twigs can be placed just outside a window where you can watch it. In fact, that same window partly open with drawn blinds can be the best possible photo blind. If it is clean, you can photograph through a single one-pane glass window. An alternative is to place a camera on a tripod near the feeder to shoot from indoors by remote control.

When photographing backyard creatures, it pays to gradually accustom them to your presence and to your activities by daily moving closer and closer to them. Avoid making sudden moves and strange noises. When you decide to operate a feeding station, be certain it is located in open sunlight or situated so that the light will favor you wherever you set up a camera.

Bird photography may be easier in wooded parts of cities and in many suburbs than in the country because many common species grow more familiar with humans and their activities. Miniature photo studios can be built on platforms just outside kitchen or living room windows and baited as described above.

Free-roaming neighborhood pets will make backyard photography close to impossible. You have to be rid of them or forget about the photography. Pets, however, can be good subjects for practice. Take the dog into a vacant field and photograph it playing, running, or fetching a stick. Children romping also make good and active subjects. You can also practice at athletic contests or events. Concentrate your photography on the center of the action.

Although photographing confined animals is less rewarding, and the environment in zoos may not be stimulating, many zoos are handy places to practice and gain experience. Some of the new cageless zoos and outdoor wildlife parks make it convenient for city-bound photographers to brush up on their techniques. For example, visit any lagoon in a park or zoo and notice the waterfowl there. During almost any season you can expect considerable action, splashing, and flushing; these are fine opportunities to practice shooting action and shooting from different angles. You might spend a week with a photography course and never match the opportunities of a single spring morning beside a park pond.

The city zoos in Portland, Oregon; Seattle and Tacoma, Washington; Vancouver, British Columbia; Calgary, Alberta; and Anchorage, Alaska, are especially good ones. Inside Seattle's Woodland Park is a small freshwater marsh, which is really a miniwilderness inside a city, but where the photo chances with wild water birds are almost unlimited. Aquariums such as those in Seattle and Vancouver are good places to experiment with underwater pictures. There are few places anywhere in the United States that are better than Northwest Trek at Eatonville, Washington, to practice shooting confined wildlife in natural surroundings (see listings under Washington in Part 3).

Visit zoos in the mornings when the animals are the most active, and the crowds have not yet accumulated. You might very well have the whole grounds to yourself. But avoid holidays and busy weekends. Take this chance to check your exposures on subjects lighted from the front, back, and side. Swing—pan—on birds or animals in motion while concentrating on sharp focus, a combination that is difficult for a beginner. Never mind, at first, that bars and people may show up in the background. The important goal here is to shoot instinctively.

Practicing with color film in a zoo can be expensive. But cut your costs somewhat by shooting black-and-white film to start. Study the results carefully to see where you made mistakes in exposure, or in not keeping your subject in focus wholly within the picture frame. Next time correct the mistakes.

Botanical parks, botanical collections, arboretums, as well as most zoos, are also good places to practice closeup techniques. These may be the best of all places to compare the various kinds of color film.

Remember that the main goal in practice is to become thoroughly familiar with your equipment. You should, in time, be able to use everything—to set your exposure, focus, and shoot—without even thinking about it.

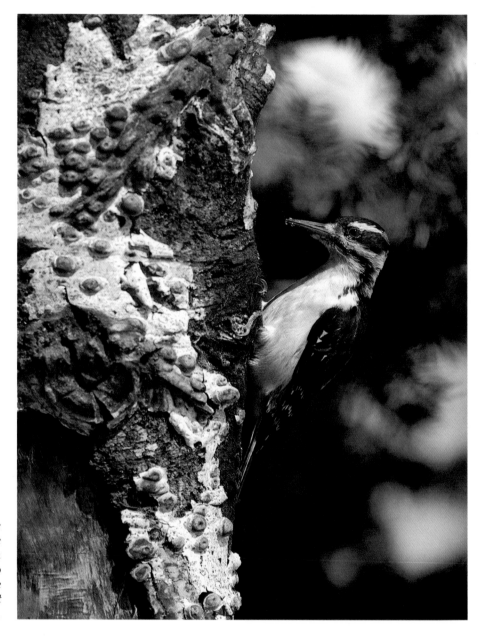

Suet stuffed into holes in the trunk of a dead tree lured the hairy woodpecker within range of a short telephoto lens. This species can be photographed in the West year-round.

📷 WILDLIFE IN THE CAMPGROUNDS

Many of the thousands of campgrounds in the West are among the best places for wildlife photography. No one intended it that way, but the careless habits of too many campers through the seasons have created a unique relationship between humans and the small creatures that live in the vicinity. Wildlife soon learns that it will find crumbs or be fed outright if it simply shows up in a tenting area. So it is now a rare campsite anywhere that does not have its resident populations of jays and nutcrackers or squirrels and raccoons.

As soon as we check into a campground, we have our photo gear handy and ready to use. Very soon we have small visitors. In Glacier National Park

Chipmunks, as well as other creatures, are willing subjects in public campgrounds.

the first friendly guest is usually a chipmunk or a ground squirrel. Across Alaska we had red squirrels, gray jays, and white-crowned and fox sparrows. Some of the sparrows would alight on our picnic table only inches away from where we were eating lunch. Once, to help pass a dismal, rainy day confined in our tent, we compiled a list of wild creatures we have found within photographable range in hundreds of scattered campgrounds from California northward. Our total was twelve species of mammals, twenty-seven birds, and two reptiles. One of the birds was an uncommon white-winged crossbill, which we have never counted anywhere else.

Our own philosophy is not to encourage animal freeloading by feeding them (because it is to their detriment). When they appear anyway, we often use the opportunity to shoot pictures of creatures that may be very shy under other conditions.

Because of the steady supply of food scraps available throughout a vacation season, populations of small mammals (especially) and birds even-

tually build up to abnormal levels. This, in turn, becomes an unfailing magnet for predators. Many of the predators venture around the camping areas only at night, but some, such as the coyotes in Yellowstone Park, become bold enough to be photographed. The only lynx we ever saw at close range was one that once lived around the Riley Creek campground in Denali. Many other camping sites have had their own resident red foxes, which thrived on the vitamin-fortified siksiks, which in turn had been fed and fattened by campers.

Especially in Washington, Oregon, and British Columbia, national and provincial forest campgrounds are located in partly or heavily shaded areas. So here is one situation where a wildlife photographer might use a small flash unit with the camera. That same flash would be useful for the fox or coyote that shows up after dark.

In some campgrounds, crinkling a paper or plastic bag is signal enough for squirrels and chipmunks to investigate a picnic table. But since a table-top is a poor setting for a wildlife picture, we lay a mossy log or limb or other natural object on the table. Every curious visitor invariably climbs on top of it, and we have a picture. It is important to avoid having any yellow nylon tents or camper vehicles looming in the background.

📷 READINESS IN THE FIELD

The best way to take pictures is to carry a *ready* camera. Failure to do so will eventually cost a photographer too many priceless pictures.

Nowadays our firm policy is to always carry at least one ready camera when in a wildlife habitat. Usually the camera is mounted to an 80–200mm zoom, which is our most versatile lens. We keep the lens and the shutter speed set at the approximate correct exposure for the moment. As the light changes, we make adjustments, even with no target in view. Often that policy has paid off in unusual shots of shy, retiring, and fleeting creatures. We can shoot quickly without having to check the exposure. If an animal happens to be less fearful, we shoot more deliberately and with greater attention to detail.

Also always have more than enough film on hand or at your fingertips. We avoid running out at a crucial time by carrying extra rolls in all pockets, even when not specifically shooting, just to sustain the habit. It is sad to come upon a willing subject, only to run out of film just when the creature becomes used to you and behaves normally. Besides our pocket film, we always keep an ample supply in our beltpack, backpack, and photo vests.

One autumn while hiking along a trail in Banff National Park, photo gear in backpacks, we spotted fresh teardrop-shaped footprints of deer etched in the soft earth. We stopped, removed our cameras from the carriers, affixed the short telephoto lenses, and continued walking more cautiously than before. We checked the available light and set the camera exposure accordingly. A hundred feet farther on there was a slight flick of movement in the quaking aspens to our left.

A splendid mule deer buck was bedded almost out of sight. Believing it would remain unseen as we passed, the buck did not blink an eye. We stopped and, without making sudden or swift motions, turned and focused the cameras on the bedded deer. Caught by surprise, it continued to sit motionless for a few seconds before the pressure became too great. Then it

stood up and bounded away. But not before we had exposures of a golden woodland scene.

The incident above was a good lesson. We were deliberately hiking in an area where we expected to find deer in the fall. Because it was the onset of the breeding season, we also knew that male mule deer would be migrating from high summer range to this vicinity. However, we were careless. We carried our cameras inside backpacks, because it is more comfortable that way. But the cameras should have been in our hands.

When setting out to photograph wildlife, be prepared by keeping a few general facts about animal behavior in mind. Big game tend to follow established game trails instead of breaking new paths. If alarmed, an individual will choose to escape upslope rather than down. Any creature will probably turn toward a cover or concealment rather than away from it. If one of a herd species (elk, antelope, or sheep) is alarmed, and there are others of the species in the vicinity, odds are good it will join them by the shortest available route. The most nervous animal in a herd will most likely dictate what the rest will do.

Wild species not under stress tend to be creatures of habit. Geese fly the same routes between resting and feeding grounds every day, unless they are frightened. Some of the best flying geese photographs were taken by photographers stationed along these predictable flyways. Keep in mind that all waterfowl will flush *into* the wind rather than with the wind. Younger mammals are more likely to play and gambol than older ones. All wildlife offers more opportunities for action photography early and later in the day than during midday.

Many great wildlife scenes are a result of being able to predict what a creature will do next. Sometimes catching the right moment is a lucky break. More often it is a result of feeding facts about animal behavior into the brain and then taking advantage of what instinct comes out. You notice, for example, a bull elk traveling rapidly in one direction during the breeding season. Ahead is a river it must cross to reach a meadow where another bull is bugling and challenging. You figure that to reach the challenger it will cross in the shallowest part of the river; that is where you wait to take your picture of the animal splashing across.

Or you notice that a deer in your viewfinder has a nervous tick, flicks an ear time and again, or repeatedly licks its muzzle. That may be the signal for a sudden departure, or it may be a tip-off that another deer is approaching. Be ready for the right moment when the two meet.

Catching the right moment also may mean never relaxing. It also involves patience (maybe more than one normally possesses), which is a virtue of successful wildlife photography. You may spend more time waiting, watching, and hoping than you do exposing film. A measure of patience is necessary, and it pays off.

We spent the best part of a cool, but sunny day on a sandspit where the Russian River empties into the Pacific Ocean in northern California. All the while a herd of harbor seals slumbered, barely moving from hour to hour. Although the potential was there, the scene of inert seals we studied through the viewfinder was not exciting.

Fortunately the hike from the coastal highway through soft sand to reach the seals was a long one. That effort probably increased our patience level, and we sat down in the sand to wait for the sea mammals to do something interesting.

It was lucky we waited. As if on some signal, the seals became restless. Some scattered sand with flippers and encroached on their neighbors'

sleeping areas causing others to protest. A few minutes later many slid into the water of an incoming tide, and we watched them chasing the eels, which were migrating unseen up the river. We even photographed them chasing squirming eels out onto the sand before pouncing on them.

It is difficult—no, impossible—to advise on how long to wait for some activity. No two situations are the same. One might wait nervously for hours in the hope that sunlight will flood a wilderness seascape, only to have the weather deteriorate. One might also lurk all day at a mineral lick where wildlife always visits, but not this time.

There are ways to make waiting more bearable as well as to make better use of the waiting time. First a photographer must be warm and comfortable. Any vigil (in or out of a blind) is easier if you have room to stretch and/or sit back to relax. Warm clothing, with emphasis on warm dry footwear, make it possible to sit in peace for a longer time. Insect repellent or a

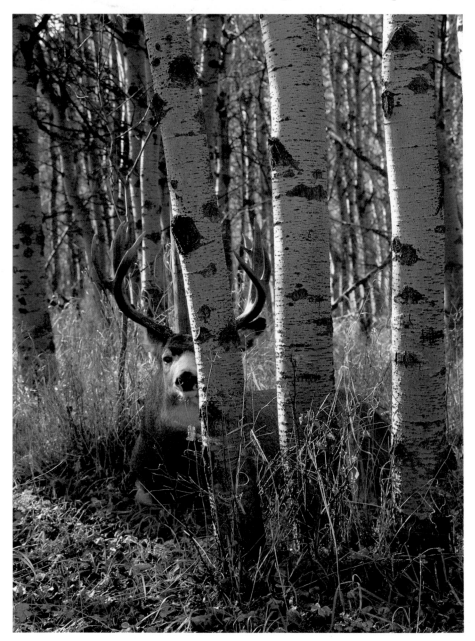

It would be easy to walk right past this Alberta mule deer buck bedded motionless in quaking aspens. Always carry a ready camera to use instantly.

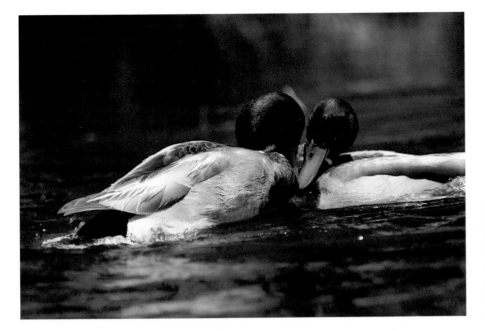

Courtship conflicts are common among many creatures in the spring. The rival mallard drakes were found on a small pond in Washington. For action, always look for males of any species during breeding season.

canteen of water can also ease the pain of staying motionless in one place for hours.

We are able to be more patient by keeping occupied. Waiting is a good time to take notes. It may also be a chance to check and clean camera equipment. Odds are that your lens glass can use at least a dusting with a soft brush and maybe a thorough cleaning with lens fluid. Sometimes it seems that taking a camera apart is the best way to guarantee action. Once, while sitting in our camper van beside an alpine lake in North Cascade National Park, we decided to wait out a rain squall by wiping every speck of dirt from every piece of glass in our camera cases. Just as all of it was spread on the small van table, we looked outside. There at the water's edge and close to the vehicle, a black bear was splashing with twin cubs. At the same instant a beam of sunlight briefly floodlighted the action. But before either of us could aim a telephoto lens through an opened window, the bear family hurried away.

But forget about the disappointments, because one fact is certain: in outdoor photography, patience is definitely a virtue.

STOPPING THE ACTION

There are times when a blurred image conveys a better sense of action or excitement than a sharp image. But too many action photos fail because the photographer did not arrest the motion.

There are two important steps to stopping action. A photographer must be able to anticipate where action will happen, and in the case of wildlife, have some knowledge of species behavior. A fast shutter speed also is necessary. To "stop" a running rabbit, or a bird flushing or flying, use the fastest shutter speed the exposure permits.

We found three mallards on a farm pond in Washington State. There were two drakes and one hen. This combination is odd, especially in springtime, and we knew the two males would eventually fight to determine

which one would nest with the hen. We did not have long to wait. Soon the drakes were shoving, biting, and attacking one another all over the small pond. When the conflict came close to us, we began shooting from behind a hasty blind with shutters set at 1/500 second. It stopped the action, although 1/1000 second would have been better, if not for the resulting underexposure.

Fuzzy action pictures result from a number of lapses, such as not holding the camera steady enough or not paying sufficient attention to focus. Blurring also results from a too slow shutter speed, no matter whether the subject is a combative mallard or any sitting duck. Normally we set our shutter speed at 1/250 second and keep it there until some combination of poor light and slow film demands resetting. Set at 1/250 second, we are ready to shoot moderate action. Of course that setting must be changed for shooting close-ups, or when we need greater depth of field.

As mentioned in Part 1, a motor-driven 35SLR is a boon in action photography. You can shoot far more frames of any very lively incident or encounter than with a manually operated camera. But there is a possible pitfall here. While it is true that a motor drive permits a photographer to better concentrate on focus and composition, there is a tendency to forget this concentration when something exciting suddenly takes place in the viewfinder and the motor is running. It is always much better to anticipate any action and be ready.

📷 SHOOTING EARLY, SHOOTING LATE

We have a Bauer theory about shooting landscapes. It is simply that the most magnificent ones are best shot when nobody else is out: early and late in the day, as well as early and late in the year. Early spring, for example, when the foliage is a fresh green, or autumn when the foliage is aflame are choice times. Our photograph of Oxbow Lake with Mount Moran looming in the distance (see title page) was taken in late September just after daybreak as the first rays of sun bathed the mountain (and its reflection) in a salmon glow.

Some dramatic landscapes are achieved by searching for unusual camera angles, either very high or low. Virtually all of the travelers who pause to shoot the Oxbow-Moran scene do so from the viewpoint parking area along the highway. But our picture was taken from almost water level with a 50mm lens, so that it was sharp from foreground to infinity.

Consider also the effects of haze and wind. During midsummer heat, the atmosphere is seldom so clear as on a September morning. Combine that subtle summer haze with a sun high overhead and even the most exquisite Rocky Mountain scene is likely to appear drained or pale. Definition is lacking. Wind is less likely to blow early and late in the day, so water surfaces are more likely to be calm. Often the difference between a placid and ruffled water surface is the difference between a good and a great landscape photo.

As we wander, we search for scenes to shoot no matter what the season or time of day. We have hiked far off the beaten track to reconnoiter photo scenes. By this scouting, and by keeping notes of potential sites scouted, we are able to set up at daybreak or at dusk to shoot scenes like that of Mount Moran. Being in the right place at the right time is no acci-

dent. Some scenes are better shot in the morning and others in the evening.

When scouting for landscapes during midday, it is necessary to calculate the path of the sun to know where it will rise and set. We have remained at a spot overnight to save traveling back to it in the dark. A change in weather or a miscalculation can foil the strategy, but more often than not, it works. We find spots in the highest meadows or where the sun shines on west-facing slopes the longest and constantly adjust the exposure settings on our cameras to be ready if a great scene presents itself. No matter what the time, exposure is such a tricky business in poor light that, when possible, we shoot at various exposures and hope to hit the right one.

Late one cold day in November in northwestern Wyoming, we were hiking on a trail crusted with snow. Our leg muscles complained, and we could feel the sudden deepening chill as the sun sank toward the horizon. It was the peak of the mule deer rut, and we had hoped to find a few of the love-sick bucks that always concentrate in this area. As yet unsuccessful, we still resisted the impulse to pack it in for the day and try again later. Some sixth sense urged us to stay longer.

The sun was almost wholly below the ridges, and except for isolated spotlights, only its afterglow remained. We quickened our pace on the back trail, heads down into a night wind, when suddenly one of us spotted it. A buck was watching us from an opposite slope. In the entire scene, only its antlered head was illuminated.

There was no time to bother with meter readings. We set our cameras by instinct and squeezed off three or four exposures before the deer stood totally in blue shadow. In our living room a week later, we flashed those slides onto a screen and were pleased.

Sticking it out late in the day is not always easy, pleasant, or sensible. But frequently, that very last light of evening has produced the best photographs of an entire day, or even of an entire trip. It is true that we have squandered much film when daylight is almost done, and that we have had as many gross underexposures as successful photographs. But the good photographs make it worth it.

Summed up, landscape photography is an anytime activity. But for the most striking results, expose film only when the sun is low in its arc.

◉ CONTRAST, LIGHTING, COMPOSITION

A reporter once asked Ansel Adams his formula for shooting the haunting, evocative black and white scenes of Yosemite for which he became famous. "I look for light against dark," the old master replied, "and vice versa." Of course that is an oversimplification, but contrast is indeed a means to powerful outdoor photographs. This is equally true with color as with black and white film.

Many scenes with great contrast may be so startling that you cannot miss them. You spot them suddenly as you drive past or trek around a bend in a trail. There could be a silver ribbon of river uncoiling in the bottom of a purple canyon; the gray skeleton of a winter maple tree outlined against a black-green spruce forest; a goat standing out against a shale mountainside in deep shadow. Many of the opportunities compose themselves, and all you have to do is aim, focus, and squeeze. But more often a photographer must compose to create his own contrast.

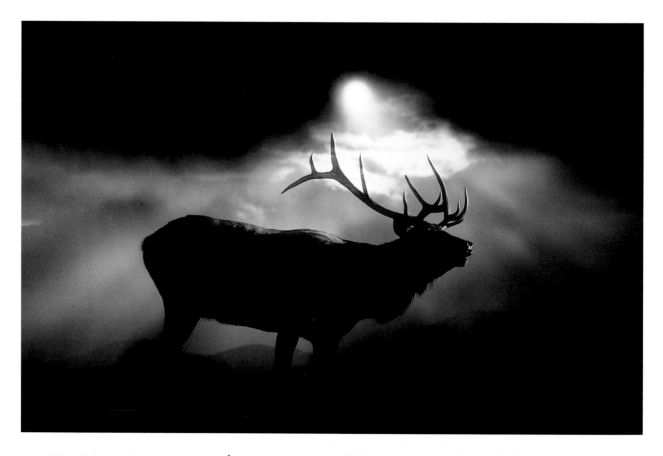

A break in evening storm clouds over Yellowstone National Park frames a bull elk. This photograph was deliberately underexposed. The last hour of the day is an important time for any outdoor photographer.

Assume you are walking on a mountain trail. Ahead an illuminated foreground subject, such as a deer or a photogenic tree, stands against an equally bright background. It looks like a good picture. But when you project the slide later, it lacks detail and is somewhat lifeless. This picture could have been improved by moving the camera position just enough to place the light subject against a dark shadow or geological formation. A shift of only a few feet can make a drab picture spring to life through contrast.

Consider the mountain goat we found high above a foot trail of Glacier National Park. Although these handsome animals are creamy to pure white in color, they blend into their habitats when photographed with the sun high overhead. But when maneuvered onto a thin ledge against a dark, dizzying background, the goat becomes an exciting subject. It is at home in an environment very difficult for photographers to follow.

The greater the contrast between subjects and background, the more difficult the exposure becomes. One or the other is incorrectly exposed. Most of the time the solution is to take a reading on the subject and set the exposure accordingly. The background will then be darker than is normal, but only rarely is this objectionable.

Although sharp stark contrast can emphasize a subject (perhaps too much), more subtle contrast is also very effective. For example, a spotted or mottled subject, such as a deer fawn, will disappear into a busy or dappled setting, as the shade of a thicket. The fawn may even pass undetected. But film the fawn crouched in the green grass, and the effect is entirely different.

To achieve a dramatic photograph of the outdoors, you also must always be aware of the sun's position relative to your own and your

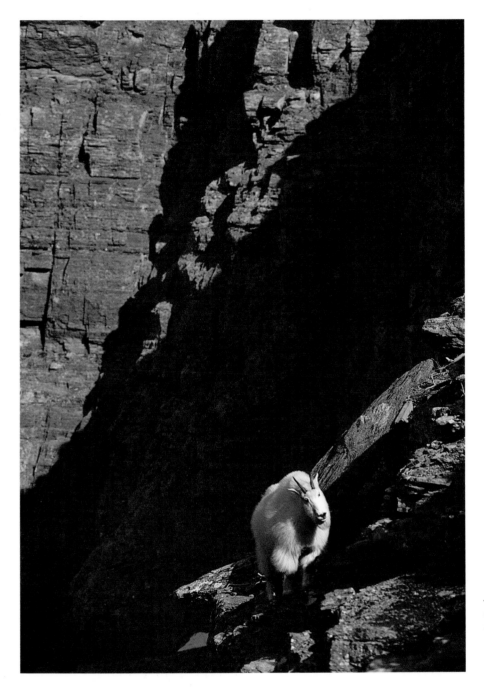

Contrast (between the light-colored goat and the dark rock faces) spotlights the mountain goat in Glacier National Park, Montana, emphasizing its dizzying habitat. You must be willing to climb steep trails to shoot goats.

subject's. Some of the finest wildlife pictures are those with the sun behind the subject instead of behind the photographer, as was once advised when color photography was new.

One late fall afternoon in Banff National Park, we followed a small band of deer for several hours, on a steep mountainside and often through deep snow. One of the group was a splendid buck especially interested in a doe, a fact that rendered him less wary of us. During our pursuit, we shot several rolls of film of the animals under a pale November sun. But our best exposure was the one of three deer backlit and silhouetted against an alpine lake shimmering far below.

A front-lighted (over the photographer's shoulder) photograph empha-sizes the shape and especially the color of the subject. But if the main

source of light—the sun—comes more or less directly from the side, the texture, physiological detail, and form of the subject are emphasized. Backlighting results in a silhouette or very dark subject and gives a photographer his chance to portray mood.

Backlighting can be particularly dramatic if the subject is slightly translucent as a bird's feathering, the thin petals of a wildflower, whiskers on a seal's face, the yellow autumn leaves, or beardlike lichens in a forest. Backlighting also can be an abstraction because modern film cannot accommodate the wide range of light that an eye can see. Therefore, obtaining the correct exposure in a backlit picture requires some experimentation, in other words, bracketing. Because we could not depend on the reading given by our 35SLR exposure meter, we set the shutter speed at 1/250 second and shot the Banff deer at several different small f/stops until the animals moved away.

Flare is a problem of backlighting. It is caused when sunlight shines directly into the lens, and it becomes more and more serious as the lens aperture is opened. Flare is also worse on smudged or dirty lenses. The problem can be solved sometimes with a deep lens shade, or by a companion blocking direct rays of the sun from the lens glass with the shade of a hat or a hand. Slightly shifting the camera can totally eliminate flare.

Good composition in a wildlife photograph can also be the result of a slightly different viewpoint. What does or does not constitute good composition will be debated as long as more than one photographer is engaged in taking pictures. If one wildlife photograph is better than another, it may be because the subject (or main point of interest) is not in the dead center of the photograph or the horizon line does not run exactly across the center. It may also mean that there are no distractions in the photograph—objects or motion that do not contribute to the scene.

Try shooting from an angle other than normal. By normal we mean either eye level (when standing up) or extended tripod height. The difference between a mediocre and a stunning wildlife study could be in a change in the elevation of the camera; the photograph could be shot from a sitting or prone position. From that lower level anything from a chipmunk or a marmot to a handsome bull caribou will appear somewhat different. Smaller mammals will seem more natural in their environment, a white-maned bull will appear more imposing in his magnificent background.

Of course it is not always possible or even wise to shoot while flat on your stomach, especially if you are self-conscious, and somebody is watching you. But be alert for such opportunities. More than once, when photographing animals in a fixed situation, we found it better to dig a simple pit blind to get a fresh focus, rather than to erect something above ground.

Sometimes there are unique problems with shooting some wildlife, notably deer, from a low angle. Although perfectly willing to accept a standing person, they become nervous when the same person drops down, perhaps in a position that suggests a predator. But it is worth trying anyway, for the deer's surprised reaction if nothing else.

There may be other times when a higher camera position is better than a normal camera stance. Many of the elevated, tree-, or tower-type hunting blinds (used more widely in Texas and the South than in the West) are suitable for this. The main advantage of an overhead blind is that many creatures do not normally expect danger from above and so do not often look upward.

Composition can often be improved by better placement of any wild creature in its environment. The first and natural inclination is to concen-

trate on the beast, place it in the foreground, and forget about its surroundings. After being assured of proper exposure and sharp focus, we make a concentrated effort to consider the important setting.

Many photographers and photography writers advocate using such natural frames in their composition as foreground trees and wildflowers or other objects. Sometimes this works well, if everything from foreground to infinity can be kept in sharp focus. But if foregrounds or frames are fuzzy (as from wind blowing the flowers or foliage), they are only distracting and destructive of good composition. Usually the most attractive photograph is also a very simple one.

At first, the photographer must make a conscious attempt to achieve contrast and good composition in his photographs. In time, this camera technique will become second nature.

CLOSEUP PHOTOGRAPHY AND THE VERSATILE MACRO LENS

The macro lens, always handy in a separate compartment of our backpack or photo vest, has often served to shoot a range of subjects from wildflowers, colorful minerals, and lichens to insects, brown bears, and trees. With that one optic alone, it is possible in a short time to photograph a whole magnificent tree in its proper setting, as well as individual leaves, buds, cones, and details of the bark, which are its identifying marks. Although filming any one of these subjects—wildflowers, insects, trees—is complex enough to fill a whole book, it is worth noting a few fundamentals to get you started.

Probably more Americans take pictures of flowers than of any other outdoor subject and with good reason. They grow everywhere in the West and almost year-round. Although wildflowers do not necessarily hold still for a photographer, they do not run or fly away as a fox or a robin. Flower photography is relatively easy, but the most striking pictures are a result of time and effort spent.

Success often depends on avoiding one common mistake—the compulsion to aim the camera and shoot one glorious scene, that mountainside carpeted in brilliant blossoms. Too often this kind of picture fails. The same fields of flowers projected on a screen are seldom as beautiful as they were to the eye. The individual blossoms blend into one another on a small slide or print. Only some of the flowers in the field will be in sharp focus. This is where closeup photography comes in. Shooting wildflowers becomes more rewarding when one concentrates on individual flowers (or berries, mushrooms, nuts, fruits, or seedpods) or on small arrangements of them, rather than an entire flowery landscape.

When we find an attractive or delicate plant, we try to photograph it from two different viewpoints: first a close-up of the blossom to reveal minute details, and then a slightly more distant view of the flower in its immediate environment. Our normal 50mm lens on a 35SLR will focus down to about twenty-four inches. This covers an area of about eight by twelve inches, which is near enough to capture some larger wildflowers or clumps of them.

But for tight close-ups of individual small blossoms, we use a 55mm

macro lens, which allows us to move within a few inches from the subject. Systems of bellows, tubes, and adaptor rings that fit between the camera and a 50mm lens are alternates to the macro lens for shooting extreme close-ups. But you cannot have through-the-lens exposure metering with these extensions, and their use is unnecessarily complicated compared to using a macro lens. Except to specialize or to concentrate on macro photography, they are not worth the trouble of carrying them.

Many photographers rely effectively on a small flash unit or a ring light that fastens onto a lens to assure a perfect exposure or at least as fill-in light in deep shadow. But for our own reasons we prefer to work with natural light alone, as well as with a natural, unaltered background.

We do not use the colored cards or sheets of cloth that are sometimes placed behind flowers or plants to give prominence to the subject. Instead we try to select flower subjects that are lighter than their backgrounds, so that they stand out. We may remove some distracting background objects, such as odd stems or withered vegetation. Or we use a larger lens opening to throw the distracting matter out of focus in the background. Light wires or twigs can be used to prop up stems so that the position of a flower can be altered slightly. Backlit flowers with sunlight illuminating petals can be strikingly beautiful. But we avoid filming flowers in the shade against a lighter or sunlit background because such silhouette pictures are rarely appealing.

Too often, however, the most attractive wild plants are growing in deep shade, or worse, where sunlight filters down through the crowns of trees, mottling the woodland floor with irregular shadows. It is more difficult to photograph in this kind of filtered light than in just poor light. One technique in the dappled forest is to isolate a single blossom gleaming in a shaft of penetrating sunshine and then to shoot it against the dark shade background. Because the range in brightness between flower and background, and between sunshine and shadow is so great here, one must expose for the flower. It is an effective use of contrast described earlier.

Shooting close-ups in shady places requires a slow shutter speed and some kind of firm camera support. A tabletop tripod works well for this, but a normal tripod, even when fully collapsed, will not permit a photographer to be close enough to the ground for ground level perspective. One solution possible with some tripods is to remove the tripod head and center post, only to reinsert it from below. This way you can shoot with the camera upside down near ground level. Another solution is to remove the tripod head from the tripod and mount it on a flat metal ground plate. (Such plates are now widely sold.)

Most of the time we dispense with the miniature tripods and plates, which become a nuisance to lug around. Instead, we approach closeup photography by groveling, often prone or on hands and knees, while using some combination of arms, elbows, lap, and legs as a human tripod. Of course we end up with muddy pants, scratches, and scrapes, but the low level view of gorgeous blossoms, lichens, or insects through a macro lens is worth it.

Getting sufficient depth of focus—getting all parts of a flower in sharp focus—is a problem of macro photography. Slightly changing the camera angle can help. But the best advice is to use the smallest lens opening that the available light will permit. Say f8 at 1/30 second instead of f4.5 at 1/100 second.

We try to save our wildflower photography for somewhat overcast days because the diffused light from a pale sky is much better for closeup

The yellow paintbrush (opposite) is only one of a great variety of wildflowers that burst into bloom with the long days and abundant moisture in Alaska. This flower was photographed in Yakutat, Alaska.

filming. Then we need not worry about losing delicate detail or delicate colors in harsh light. Days that are both dull and damp may be the best of all for wildflower photography.

Wind, which is usually perfectly still until we are ready to begin shooting flowers is always a factor. At such close range, even the slightest breeze can affect a flower enough to blur a picture. So while one grovels, handling the camera, the other holds a small portable windbreak. A sheet of Plexiglas makes a good windbreak, because it is transparent and does not block out light. A person alone can set up a windbreak by stretching a sheet of cloth between upright rods in the proper place. But closeup photography of fragile plants is seldom successful and often impossible on very windy days.

Perhaps the best times of all to search for wildflowers are on damp, dewy, early spring mornings, when fresh new blooms are sprouting every day. In the Northwest it is not uncommon to find flowers (such as sage buttercups or pasque flowers for example) poking up through the melting snow. In winter the same closeup techniques can be used to photograph mountain ash, rose hips, pine cones, and a hundred other things.

Early mornings, when it is still chilly, is also the best time to photograph insects and butterflies, because they are not as active. Soon after the sun warms them, butterflies seldom pause long enough for serious photography. But like many other insects, they can be carefully caught and briefly cooled to render them almost inactive. Then they can be positioned in a natural setting, as on a flower, and photographed.

Butterflies and moths as well as many other insects can be found around carrion and rotting fruit. They can also be baited with sweet-smelling concoctions of honey, cider, sorghum, molasses, and beer and placed around flowers, or wherever convenient. Many insects are easier to approach within macro lens range when they are mating. Others, such as dragonflies tend to use favorite perches around wetlands, and it is often possible to catch them motionless there. Spider webs, especially with the resident spider, are always fascinating to photograph, particularly in low morning light when the silken webbing glitters with dew. Try shooting any spider web soon after daybreak with the light behind it, but do not bother if even a slight breeze is blowing.

Once on a cool summer morning near Moose Pass, Alaska, we sat on a bluff overlooking a shallow, alcohol-clear stream alive with spawning sockeye salmon. We hoped to photograph bears fishing for the salmon. Bear sign was so abundant that it gave us an uneasy feeling. Bear manure was widely scattered in the vicinity, including where we set up our tripod with camera and 400mm telephoto lens.

After an hour no bruins appeared, and we relaxed and became fascinated with other life around the spawning site. A red fox materialized across the creek, did a double take when it spotted us, then vanished. Next we studied the scarlet fish moving in the clear current just below; many were actually spawning in a riffle too shallow to cover them. With no bears in sight, we decided to try to film the salmon. While one crept close to the water's edge, the other maintained a lookout for bears.

By sitting and scooting on the seat of our pants, we inched toward the stream, and eventually sat down in the middle of it. This flushed the salmon nearby, but in a few minutes all were back again. Several wallowed only two or three feet away. Suddenly a male salmon with its grotesque hooked jaw darted forward and briefly became stranded on smooth gravel, almost entirely out of the water. It was easy to turn and with a macro lens shoot several close-ups of the final moments in the life of a sockeye salmon.

The bears did not come to feed until dusk, when it was much too dark and unsafe to linger for photography. But the colorful salmon had more than compensated.

Shooting close-ups in no way matches the adrenalin rush of stalking a Yukon grizzly, but it is a rich and absorbing pastime that adds years to a photographer's life. Down there on the forest floor you discover smaller flowers and creatures you have never encountered before, you find strange fungi in the leaf litter and insects as colorful as the fish of a coral reef. In fact, closeup photography alone can consume a busy lifetime outdoors.

PHOTOGRAPHING BIG GAME: HOW AND WHEN

Whether you seek the challenge of trophy hunting with a camera and color film or the excitement of capturing the drama of the rutting season, big game photography can be a consuming and rewarding activity. How and when to photograph big game requires knowledge of their behavior, care in approaching them, and a willingness to make plenty of footprints in the wilderness.

Let us first clear up a possible misconception. With only a few exceptions, it is a waste of valuable time to attempt to photograph the big game of the West where hunting is allowed, and the animals are actively pursued during annual open seasons. The targets are simply too shy and suspicious of people. Of course it can be an immense challenge to take good pictures of elk, sheep, or bears under such conditions, but we prefer to do our big game shooting in parks and sanctuaries where the wildlife does not unduly fear people. It is more productive. That way the photographs we make are mostly of animals behaving naturally, perhaps with some apprehension, but not racing away. This is not meant to be an indictment of legal, regulated hunting in America today. It is just a statement of our philosophy about wildlife photography.

Certain species become tolerant of human presence more quickly than others. A few park animals become as used to people as they are to the trees and rivers. In open hunting areas no mammal is more wary than the bighorn sheep; protected in the national parks of western Canada, bighorns often graze along the highway's edge, and trophy rams have strolled up to our parked car to lick road salt from the tires. Black bears also fall into this category. Where actively hunted they are rarely seen, even in the distance. But in parks they can soon become panhandlers and a nuisance.

As a rule of thumb, wildlife is most confiding and tolerant of photographers in direct ratio to the time it has been protected. So the best big game photography parks in the West are also the oldest. These are also the best places for a photographer to go trophy hunting for big game.

How close can you approach an animal? Remember that even in the most popular national parks, and despite its visibility, wildlife is never *tame*. Each species and each individual has a tolerance limit—an invisible boundary—beyond which a photographer cannot or better not advance. Watch the ears, eyes, and hair on the ruff, and the tail of any antlered species, and in time, you will be able to read its intentions. A nervous deer, for example, is one that nudges another, appears uncertain and flattens its ears. So keep

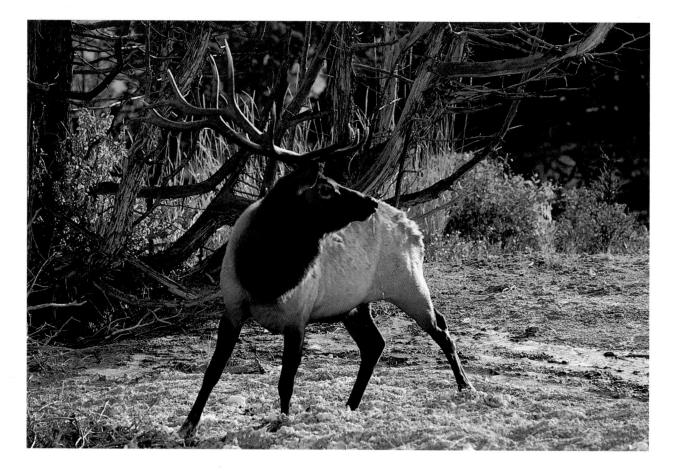

The vicinity of park head-quarters (at Mammoth) in Yellowstone National Park, Montana, is the best of all places to find trophy bull elk every September and October. This prize was shot using 80–200mm zoom lens on a hand-held camera.

a good distance away, make no sudden movements, and use a long tele-photo lens.

Any wild animal's senses—hearing, sight, and smell—are much more acute than a human's. Therefore, it is seldom possible to get within reasonable camera range without being detected. To attempt most wildlife photography by trying to stalk stealthily, unseen, as a hunter with a rifle would do, results in failure. Pictures of the back ends of frightened animals vanishing in the distance have no value.

When approaching a large animal, we do so in plain view, yet indirectly, by pausing and changing paths. We avoid walking directly or purposefully toward a target. We avoid eye contact, and we try to give the impression that we scarcely notice our eventual subject. We stop often to make an exposure or two in case we never get any closer. This is good advice to anyone who is unfamiliar with the species in a particular place. If a subject does show signs of nervousness, we often sit down nearby or even retreat a distance to appear disinterested until the animal becomes used to us. We are convinced that many animals in parks would rather keep a person in sight at a tolerable distance, than lurking somewhere out of sight.

The most exciting and reckless time in the life of big game animals takes place every autumn. It is the rut or annual breeding season when males are far more active than at any other time. The dramatic action—males confronting, bluffing, dueling, and vying with one another for breeding privileges—also makes it an ideal time for trophy hunting. Go where big game concentrates, and there will be few dull moments in the fall.

For some species, such as the pronghorn antelope and elk, the rut

begins early in September. Mule deer breed in November, bighorn sheep usually in December, depending on latitude and weather. The intensity and duration of the rut is determined by a process called photoperiodism, which works somewhat like exposing film.

A buck or bull's sex drive is stimulated through its eyes (or lenses) by the decreasing daylight of fall. So the males begin the frantic search for females, which come into estrus at the same time. Many males behave foolishly and temporarily become less wary of humans.

Contrary to the scenes we see in calendar paintings, it is only rarely that the trophy or master bulls do any fighting. Most have already established themselves and need only to bluff and display horns or antlers (good picture opportunities) as their credentials. But when our purpose is to find the most thrilling action, we always seek out the younger, aspiring males, and the more in a herd or a vicinity, the better. These not quite fully grown bucks and bulls are the ones that keep a photographer on his toes.

It is often possible to locate young males by the sounds they make. We first heard the rattling of antlers in the distance in Grand Teton National Park. That meant bulls fighting. Carrying our gear in photo vests, we zeroed in on the noisy clash, and quickly came upon not two, but three bull moose in the process of plowing up a grassy glade with large hooves. For ten minutes or so the trio contested, and we followed them in our viewfinders. The prize, a sleek black cow moose, did not even look up from browsing on willow tips or even seem to notice that anything was taking place. While we were pausing to change film, a fourth moose, huge, glossy-coated, and with antlers almost as heavy as the others put together, arrived on the scene. With nothing more than body language, it sent the young bulls away and spent the next few days entertaining the cow.

We do not believe that animals are as dangerous during the rut as some writers have claimed. The animals are too preoccupied with the business of breeding to be bothered. It is more important to avoid a cow moose with a young calf in the springtime. But still there is a limit of tolerance, and at least twice we have seen bull elk turn on photographers who ventured too near to the animal that was not faring too well in the quest for love in the first place. So the most sensible advice here is to shoot the battles of autumn from a reasonable distance with a telephoto lens. (See Further Reading for detailed reference books on big game animals, where and how to find them, and how to photograph them.)

To shoot the trophy in adequate light and setting, the photographer must approach a lot closer to the quarry than a gun hunter, which is not easily accomplished. Although the photographer may be fascinated by every living thing, his adrenalin pumps much faster when he confronts a magnificent stag or ram in the viewfinder. It is easy to understand how trophy hunting can become an addiction. As we vagabond the West, we are always trophy hunting.

Although we have devoted countless days and hundreds of hours to filming hundreds of mule deer, one handsome male Alberta animal was the grandest of the species we had ever seen. We spotted the animal from far away several times in mid-November before finally being able to maneuver into telephoto lens range. The buck had traveled from remote, alpine summer range to a low valley where the rut would soon begin. Because it was less cautious than normal during the rutting season, we were able to make the portraits through a 400mm lens. The results more than compensated for the many trophy hunts on which we were not successful.

Head hunting can vary from the almost impossible to ridiculously easy. Our mule buck fell somewhere in the middle. Once in Yukon's Kluane National Park, we shot a trophy Dall ram standing beside the Alaska Highway. We also "bagged" a 15-point bull elk in the Olympic National Park; a normal, fully grown bull elk has 12 antler points, 6 per side.

Any good, sharp picture of a mature game species in a wild environment is a valuable trophy. But a serious trophy hunter searching only for top heads must learn to distinguish between an outstanding and an average rack of antlers in the field. With experience this becomes easier and easier to do.

Roughly speaking, trophy antlers (of deer, elk, moose, and caribou) will extend outward well beyond the tips of the ears, when the ears are in the normal position. The antlers also should be higher than the length of the animal's face, and the more the better. Trophy sheep horns should be thick and heavy throughout their length. Each horn should also come as close as possible to describing a full circle. The best view for trophy judging is directly from the front, but side views give additional support to judgment.

In lieu of frequently seeing and judging many animals of a species, make comparisons by consulting the *Boone & Crockett Record Books of North American Game* (available in most libraries) to see how big game heads are measured, evaluated, and scored. It is also worth looking into trophy galleries, taxidermy shops, or natural history museums for information.

We are convinced that the trophy photos in our files have provided as many thrills and are far more satisfying than all the stuffed, glassy-eyed heads we have ever seen.

📷 BEARS

Like most other busy wildlife photographers, we have always been fascinated by bears. But (with a few exceptions) they are not easy to photograph in the wild nowadays. South of the Canadian border, grizzlies are rare; north of it, they are elusive and shy. The days are gone when black bears panhandled along national park roads. Several sanctuaries in Alaska (Denali, Katmai, McNeil River) remain the only dependable places to see bears.

Like many other large mammals, bears (especially black-phase black bears) tend to be darker than their environment. So the proper exposure should be of the bear itself, rather than of the scene. Bears are difficult in another sense, too. Unlike deer or moose, a bear may almost never show its recognition of a nearby photographer by lifting its head. Nonetheless it *is* aware. Making strange noises or sudden movements to get the animal's attention are likely to succeed only in driving the animal away or in provoking a rush. Patience is the best answer. Bears are potentially dangerous animals, especially to any photographer who does not regard them as such. During the past three decades we have spent much time in top bear country, including two summers concentrating on bears for our book, *Bear in Their World*, and have met hundreds of different bruins. But except for a polar bear encountered in northern Manitoba, not one ever behaved aggressively toward us.

Whenever we are in bear country, especially grizzly or brown bear

country, we watch for them studiously and constantly. When spotted, we give them a wide berth. But when trekking wilderness trails in the West, we do not walk whistling and ringing bells. In too many places that noise simply alerts a bear to the presence of a person who probably carries goodies in his backpack.

We always keep a scrupulously clean camp, while realizing that earlier campers on the same site may not have done so. Except for the safety of our car or within reach of it, we will not even aim a camera at a grizzly sow with cubs, or for any reason get between the mother and her cubs. Instead we make tracks in another direction. A mother grizzly is the most determined of all bears. Photographing bears is the best justification of all for investing in a long telephoto lens.

All of this may sound overly cautious to photographers who have long filmed bruins without incident. But especially in sanctuaries where they have not been hunted for many years, there are signs aplenty that bears are, indeed, becoming less fearful and more aggressive toward humans. So a word to the wise should be sufficient.

FOCUS ON THE EYES

Many times the lack of sharpness—the loss of detail—is all that prevents a poor or mediocre picture from being a very good one. This is most evident when you project a slide onto a screen and find it to be fuzzy or soft. You can see the form and outline of the bird or beast, but not the details of its plumage or horns. You might be able to bring the picture into greater sharpness by focusing the projector lens, but if the slide itself is not sharp, it cannot be improved in projections.

Focusing accurately all the time is a discipline that demands concentration. We constantly remind ourselves to be absolutely certain that any scene or subject is as sharp as possible in the viewfinder. Focus is easy to neglect when a subject is very active or exciting.

When photographing any wildlife, always focus on the bead or the highlight in the eye. To do so is to assure that at least the whole head will be in sharp focus. Many wildlife pictures suffer only because of the dull or opaque look in the eye, or because an eye is not visible at all or is in a dark shadow. Watching the eye as you aim the camera may also reveal what the animal might do next.

There are other ways to increase sharpness, and one is to inspect the focusing screen of the 35SLR camera you use. All popular camera systems today offer a selection of different screens that fit (interchangeably) into the viewing apparatus. A photographer should test several different focusing screens to discover which one gives the most positive results. A lot of 35SLRs come standard equipped with matte fresnel fields with circular, split-image rangefinder spots, because manufacturers consider these best for general photography. But many professional outdoor photographers prefer a focusing screen with overall fine-ground matte field.

Most 35SLR systems also include a choice of eyepiece correction lenses, which screw into the viewfinder eyepiece. These are designed to permit both nearsighted and farsighted users to view and focus without their prescription eyeglasses. A soft rubber eyecup, which prevents extraneous light from entering the viewfinder, can also be valuable.

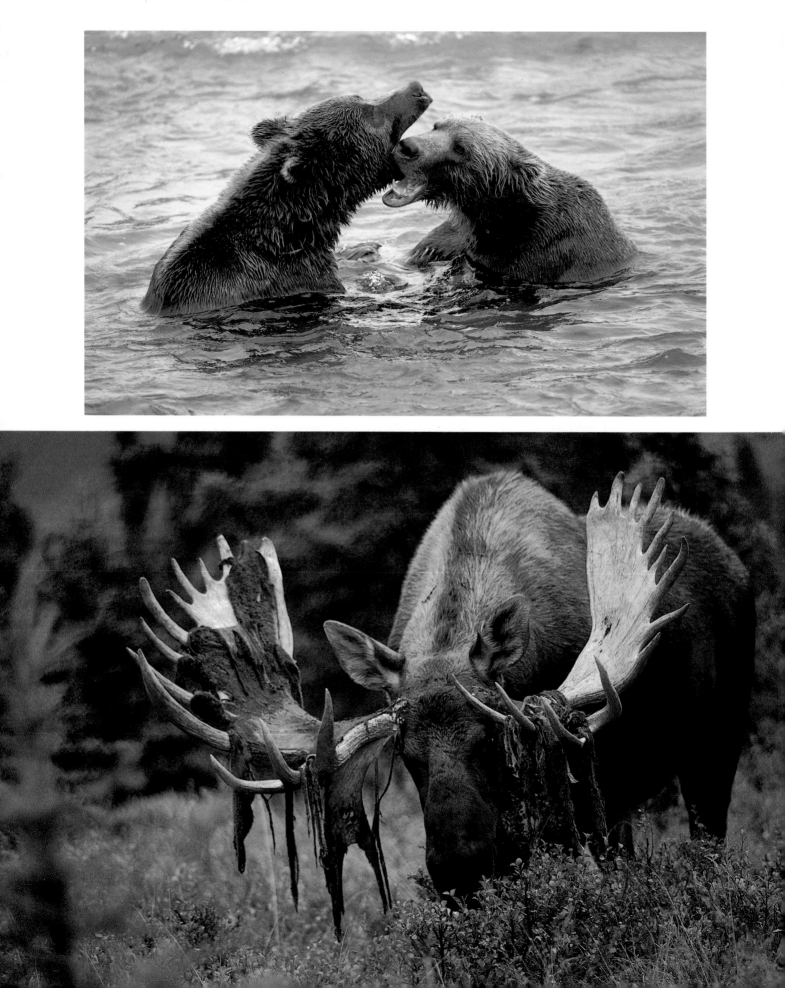

SHOOTING FROM THE WATER

We never miss an opportunity to go hunting for wildlife from a boat, a strategy that often carries us within point blank range of everything from surfbirds and sanderlings to a brown bear feeding on a sea lion carcass. Many creatures will permit a much closer approach by boat or from the water, than from land. The West offers numerous opportunities to shoot the wilderness and wildlife from watercraft, any kind of watercraft. A typical run on the Alaska Marine Highway (the Alaska State ferry system) from Seattle to Haines or Skagway is the best possible means to photograph the splendor of the Inland Passage. Photographing from a canoe or kayak gives us a radically different, but equally spectacular perspective. Some great scenes simply cannot be photographed at all, except from waterside.

The scene of the Steller sea lions basking on rock islets and cavorting in the water was made in Resurrection Bay, Kenai Fiords National Park, not far from Seward, Alaska. To shoot the picture, we stood on the gently rolling deck of the MV *Spirit* with fifty or more other photographers, who were aiming telephoto lenses toward the same sea mammals. The click of shutters and motor drives resembled a cricket chorus on a hot summer night.

Although our day spent on the *Spirit* was a remarkable opportunity to film sea otters, puffins, cliffs white with kittiwakes as well as peregrine falcons, harbor seals, and whales, it was not unique.

Some creatures can be approached by boats because of their familiarity with them, others because a freely drifting craft makes far less noise than a human on foot. It is a stealth factor. For example, the same sea lions, which tolerate the almost daily close approach of the MV *Spirit*, would plunge into the sea the instant a photographer appeared on shore. They are accustomed to having watercraft draw near, but a person on foot in that isolated place would be difficult to comprehend.

More than once while with Roy Randall (of Afognak Wilderness Lodge) on Afognak Island, we have been able to drift silently toward a lonely shoreline on which a bruin was foraging. At least once we drifted too close for comfort. Suddenly, through the viewfinder (and filling it), we saw the bruin just as it realized our presence. For a tense instant it stood undecided whether to run or plunge out into the water. Fortunately, this one ran.

Any kind of boat photography has special demands. All camera equipment must be kept dry and protected from spray and from falling overboard. That is doubly true if in salt water. Never shoot without the camera strap around your neck. When in rough water, position yourself (or fasten yourself) so that you do not go overboard, no matter how absorbed in the shooting.

A fast shutter speed is necessary to compensate for even the slight movement of a seagoing craft. On a large craft, there is the least motion standing near the center (as opposed to being on the rail). It is advisable to keep checking the exposure, especially along a seacoast, where light values can change with the slightest change in camera angle. Wet shorelines

Young male brown bears (opposite) erupt in play-fighting in cold McNeil River, Alaska's, and possibly the world's, finest bear sanctuary. Fast shutter speed stopped the action.

It is late summer, and the velvet is peeling from a bull moose's antlers in Denali National Park, Alaska (opposite). A photographer should not crowd a moose in rut. Focus on the eyes to achieve sharpness all around the head.

washed by a surf are brighter than dry ones. When a day's shooting is finished be more than normally meticulous when cleaning all the equipment you have used. Moisture, especially salty moisture, is an enemy.

We keep our equipment dry in plastic bags or in waterproof carrying cases when not actually being used. We blot or wipe off spray when it does fall on equipment. When on a boat deck, and not actually shooting something, we wear the camera around our necks underneath a rain parka.

📷 DISCOVERING THE ROOKERIES

An outdoor or wildlife photographer living on the coastal West has an unusual opportunity to photograph rookeries. These range from sea-birds nesting en masse on islets and oceanside cliffs to beaches where several species of marine mammals haul out. It is fascinating to spend time on the fringe of such concentrations. But the photography requires care and finesse.

Few rookeries are easy to reach, which is fortunate for the nesters, and no doubt explains why the rookery is where it is. Certain vulnerable rookeries on national wildlife refuges are off limits, period. A too aggressive photographer can cause the occupants to desert.

It is best to stay far away from rookery areas when the birds first begin to arrive in the spring because that is when they are most likely to look elsewhere if they are bothered. Rookery areas can be studied from a distance through spotting scopes to save alarming the birds and to save a lot of personal effort. Our first move is not made until the birds have settled down for the nesting season and after at least some eggs are laid. Once chicks of most seabird species hatch, the parents are kept too busy feeding the young to be bothered with discreet photographers.

To photograph a rookery, you must first determine if it can be reached safely while carrying all photographic equipment and a portable blind. Because distances from camera to subject may be long, a firm tripod is also a necessity. It may be necessary to consult tide tables because many nesting islands are severed from land by a strong surf except at lowest tides. It is vital to determine if there is a suitable place or places from which to shoot. Birds that nest on sheer cliffs may be impossible to photograph unless there is a camera vantage point facing them.

Once we find a suitable spot, we set up a blind that can withstand wild winds and rain. It should be positioned a long telephoto lens distance from where there is much activity and in good morning or evening light. In the blind we are only a motionless part of the landscape. If the nesters pay no attention to us, we may move the blind closer and closer in stages.

We have had some nesters—puffins and auklets—land and preen only a few feet away. We photographed murres in Alaska's Pribilof Islands, which contain some of the most photogenic rookeries on the continent. The archipelago is difficult and expensive to get to, but the opportunities for photography during an early summer season are immense. Besides the birds, great herds of northern fur seals breed on Pribilof beaches every year. Several seal haul outs are easy to reach on foot from the Aleut communities of Saint Paul and Saint George where there are accommodations.

The marine mammals of the West (Steller sea lions, harbor seals, northern fur seals, and walruses) haul out on traditional beaches from

northern California to the Bering Sea. They bear young and breed at about the same time the seabirds are busy nesting. And often the same precautions and techniques are necessary to photograph them. The main problem is that the maritime weather is not always conducive to the best shooting.

○ SCENICS: SEASCAPES AND MOUNTAINS

From Yosemite northward to the Aleutian Islands, it is difficult to say which are more magnificent, the mountainscapes or the seascapes of the West. A photographer could devote a lifetime to shooting either of these.

Despite the West's spectacular scenery one can lose the true grandeur of a scene by just pointing the camera and pressing the shutter. Countless parking areas and overlooks along highways paralleling Pacific coastlines or along mountainsides make it handy for a person to pause to take pictures. They are not always the best viewpoints though, and a serious photographer should not settle for these.

For us shooting scenery involves a good bit of hiking and climbing, because we are seldom content to photograph from the same spots used by thousands of other photographers. By climbing nearer to the water's edge or away from well-used trails, we search for a more awesome or unusual viewpoint.

Our photo was taken in the Bugaboo Mountains of British Columbia during a helicopter (heli-hiking) hiking trip in that picturesque range. These adventures are noteworthy because in minutes a helicopter transports a photographer onto active glaciers and even to the glittering, exquisite world high above for unique and lofty camera angles. We felt slightly guilty reaching wilderness places heretofore accessible only by a two- or three-day arduous backpacking trek on foot. But it was a novel experience, and we can strongly recommend the adventure to aspiring alpine explorers who are physically unable to start from scratch.

All scenics should be done with care and not just hurriedly composed and snapped. The first, perhaps most common error people make is trying to include everything the eye sees into a 35mm frame. It seldom works. With seascapes select or try to isolate one most compelling section of the whole view to be the representative picture—steep shoreline cliffs, the pattern of white waves washing onto a dark beach, jagged rocks standing off shore, or sanderlings at the edge of the surf.

The light on all scenes changes constantly. Much time and hard work can be invested before catching a landscape just right. But mornings and evenings are invariably best. Shadows are harshest at midday, and these contribute to less appealing pictures. The same polarizing filter, which darkens a sky and emphasizes clouds early and late, offers little advantage for several hours around noon. We wait in a suitable camera position at first and last light. On the coastline, this is when all the colors are deeper and richer, and when coastal fog may be drifting shoreward.

Color and mood in some seascapes can be altered by three kinds of filters. A polarizing filter reduces or eliminates reflective glare from water (depending on its adjustment) and can produce more intense colors. But it will not change the hue. How much a polarizer reduces reflection can be seen in the viewfinder.

An ultra-violet (or UV) filter can be used here to neutralize the effect of

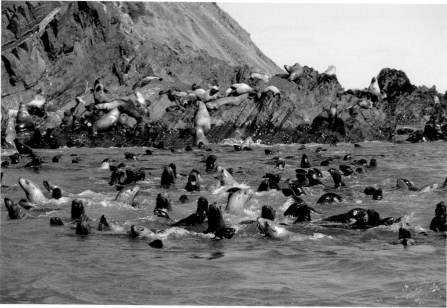

Steller sea lions may be best approached by boat, as here at Marmot Island, Alaska, where they are accustomed to watercraft. Some have actually come out to meet the camera boat from a haul out on shore. Use fast shutter speed to compensate for the motion of the boat.

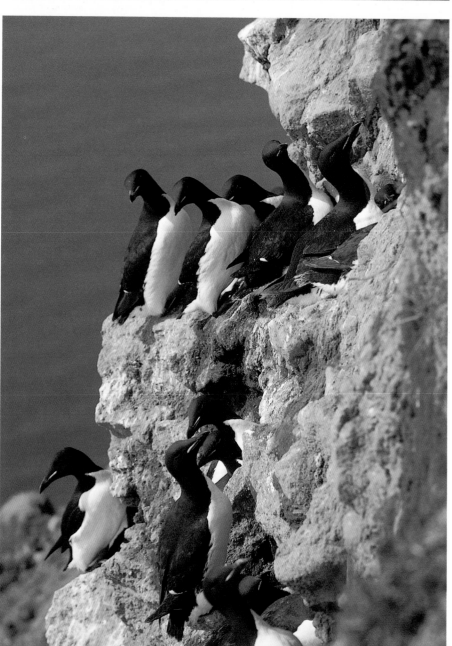

These murres are resting on the sheer cliffs of Saint Paul Island in Alaska's Pribilof Islands. The photograph was taken from an adjacent cliff using a telephoto lens.

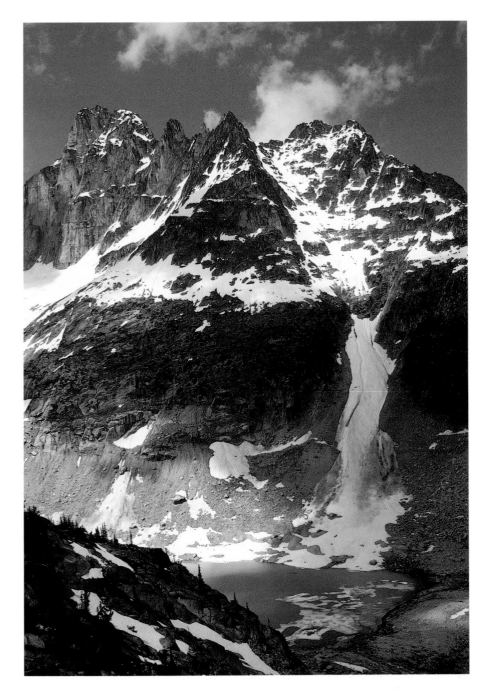

Alpine scenes of stunning beauty are now accessible by heli-hiking trips in the Bugaboo Mountains of British Columbia. Comfortable hiking boots and backpack are as vital as camera gear. It is also important to be in good physical condition.

ultra-violet light and thereby reduce haze in scenes. But this reduction is slight and probably not worth having another piece of glass to keep clean. A neutral density filter, which reduces the intensity of all light in a picture, does not change color. These filters can be used on the brightest scenes to slow down shutter speeds and achieve special effects. We use half neutral density filters (in which only half of the glass is darkened) for darkening skies only, while not affecting the rest of the picture.

The lenses most often used for seascapes are the short ones, from a 50mm to a 200mm telephoto. The 50mm is used for shooting a fairly long view of a Pacific shore. We change to a 200mm when we want to emphasize an inlet or small section of beach or a geologic feature. Zoom lenses such as the 80–200mm are ideal for this because they can spare a person much

scrambling to change positions. One zoom lens is lighter to carry than several smaller lenses.

We shoot some mountain scenics, including the one of the reflected Bugaboos, with a 50mm or 55mm lens. More often we turn to a short telephoto or zoom (say 80–200mm) lens, although a 50mm or even a wide-angle lens is most likely to accurately record what the naked eye sees. In a color picture, that may be too much. What is a spectacular cluster of mountain peaks to the eye becomes only a distant line of undistinguished humps when shot through a short focal length lens.

Wide-angle lenses must be held parallel to the ground, or vertical lines (as of trees, canyon walls) tend to lean or converge unnaturally. Many photographers who specialize in landscapes use large-format cameras (unlike 35SLRs), and convergence can be avoided by tilting the plane of both the lens and the film.

A photographer can certainly hand hold a camera steadily and take a good sharp picture that way. But it is wiser to use a tripod, especially if using a telephoto lens. The tripod allows a slower shutter speed and a smaller lens aperture for greater depth of focus. It also permits the longer exposures that blur the motion of waves rolling onto land. It compensates for wind and unsteady human hands. However, when a great depth of focus is not a factor, as when we do not have foreground subjects to consider, we use a fast shutter speed such as 1/250 or even 1/500 second to compensate for any wind, which is common at high altitudes or along beaches. A brisk or gusting wind can cause even a tripod-mounted camera to move.

Camera steadiness is not the only reason to use a tripod for mountain landscapes. The photographer is also subtly encouraged to take a little more time with composition and to make minor changes in position for better results. A slight shift left or right can eliminate some distracting object in the foreground, or it can better mirror a scene in an alpine lake. With a tripod mount, a cable release can be used to minimize camera movement. Tripping the shutter with the self timer also reduces vibration. On many 35SLRs the mirror can be locked up (after the picture is composed in the viewfinder) to further reduce camera movement.

🄾 EXPLORING THE WILDERNESS

As soon as the morning sunlight flooded the steep, east-facing slope above our campsite, we spotted sheep far above in an alpine meadow. Studying the animals through binoculars revealed the heavy, curved horns of rams, possibly very large ones. We wasted no time with a leisurely breakfast because a quarter of a mile straight above us a wildlife photographer's dream was waiting—a clear, stunning morning, magnificent subjects, and the stupendous background of the southern Alberta Rockies. It was a combination too rarely discovered.

Our campsite was still in deep cold shadow as we shouldered backpacks laden with our photo gear, clothing layers, water, and chocolate-raisin-oatmeal-almond gorp to begin the climb toward sunshine. The first part of the hike was relatively easy because we were fresh and still in shade. But the farther we traveled, the more difficult it became. Backpack straps dug into our shoulders, and sweat ran down our backs. We had to slow our pace.

When we seemed to reach a dead end—a rock face too steep to scale safely—we had to search for a long way around. By following sheep trails we found it. Suddenly we reached a bench where we stared squarely into the amber eyes of a bighorn ram. A ewe stood a few feet away against a rock fall. Neither animal appeared especially surprised or alarmed to see us. We sat down for a moment to rest and regain strength in our legs, which were as weak as worn-out rubber bands. We ignored the sheep for a while. When a second ram arrived nearby, we began to slowly uncover the cameras from our packs.

What followed for the next two hours, before a heavy gray overcast rolled into the valleys below us and crept rapidly up the mountainsides, was a remarkable (and too rare) shooting session. We followed these bighorns and others in the vicinity, filming all from close up and afar, but always with astounding backgrounds. Many of the exposures made that memorable morning have been published often.

The lesson here has nothing to do with cameras or photography techniques. Our success that morning was possible only because we were in good physical condition. Unless we had started climbing promptly and continued without delay to the sheep, we could have missed an all-too-brief opportunity.

If it seems odd to speak about physical condition with nature photography, be assured that this incident was not unique. Quite frequently, being able to hike or climb well and race against time has been the difference between winning and losing with both wildlife and the weather. We keep in shape with daily vigorous hiking and have learned that after the first heavy snowfall, cross-country skiing is an even better conditioner.

Just carrying the equipment necessary for wildlife photography requires some effort. The common tripod, tripod head, 35SLR with motor drive, and 400mm lens weighs twenty-five pounds to start out and three times that much halfway up any steep trail. Strong legs, a strong heart, and lungs come in handy. Develop these, and you will feel better, even if you never aim a camera at anything.

There is an equally important case to be made for just getting out and about in the wilderness. The most photogenic areas of the entire West lie well beyond the pavements, the parking lots, and the most heavily used hiking trails. Much wildlife is out there waiting to be discovered by a vagabond photographer.

A walking or backpacking venture has multiple advantages in the West. No section of this continent offers so many appealing destinations, and most of the best of these are listed in Part 3 of this book. It is especially exciting to hike and explore any scenic trail for the first time. Everything you see is a revelation, and you are likely to notice more new subjects than if spending the same amount of time on an old familiar trail. Many of our finest days have been those spent exploring with no specific goal or destination in mind. With a good enough assortment of photographic equipment in our packs, we are ready to shoot almost anything we encounter. Hiking close behind the retreating snow or the sudden coloring of foliage is a perfect way to celebrate spring or autumn.

Once in the Olympic Mountains, we awoke to find a mountain goat nanny with a kid standing belly-deep in purple lupine not far from our tent. Both seemed to be puzzled by our strange yellow shelter. Later at the same campsite we were entertained by a family of hoary marmots, which had excavated a cluster of underground dens in the vicinity.

Mucking around in a marsh, bog, swamp, and beaver pond is another

rewarding possibility. Many swamps teem with wildlife. Although often difficult to negotiate on foot, especially with mosquitoes and deer flies buzzing about the ears, Western bogs are broodingly beautiful places for a photographer to explore. Some of the most interesting days we have ever enjoyed afield have been in marshes where it was difficult to lift one foot after another from the muck and ooze.

One way to get acquainted with a wetland and get good photos there is to play the waiting game. Go before dawn when it is coolest and eeriest, find a dry log or deadfall, and sit there quietly. Tune in to the sounds all around. As often as not, a variety of wild creatures will materialize and some may venture very near. Kingfishers may alight within range of a 200mm lens. Bullfrogs will surface and belch nearby, and water snakes stalking frogs will swim close by. We have located the nests of many furtive water birds just by sitting and watching from a beaver dam.

Unless you are already attuned to swamping, you will need chest-high trout fisherman's waders or hip boots. For us the waders are too heavy and too hot. From May through September, blue jeans and old sneakers are uniform enough. More important than waterproof footgear is a dependable carrying device for camera and lenses, which also leaves both hands free for balance. More than once we have used (of all things) a ski pole as a wading staff in a marsh with an uncertain bottom. A screw head at the handle of the ski pole allowed it also to be used as a monopod.

Some marshlands are better traversed by shallow-draft boat or canoe or kayak, than on foot. And nearly all are more seething with life soon after daybreak and just before dark than during middays. Night is probably the best of all. Any photographer with a headlamp, a flash unit attached to his camera, and an affinity for the dark can have the greatest success of all

Bighorn sheep rams posture during the annual rut in Jasper, National Park, Alberta (an excellent place to find bighorns). A tripod and a telephoto lens make it possible to fill the picture frame.

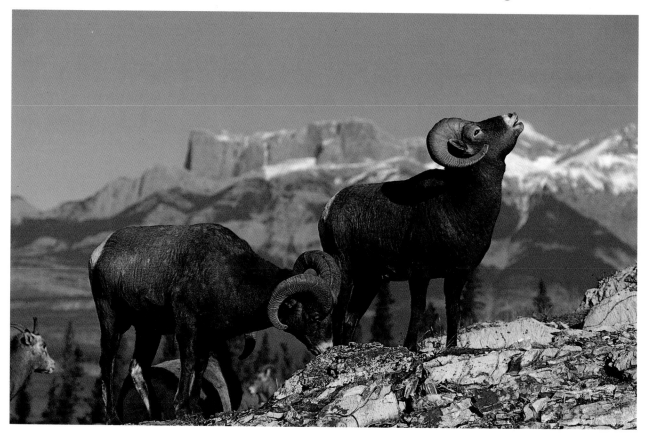

mucking around in a marsh.

One final word: mosquito repellent can be the wetland photographer's best friend.

LEARNING FROM GROUP EXCURSIONS

Nature photography is not really a social pastime. One or perhaps two completely compatible people working together can accomplish a great deal where just one more photographer would drive the subject away. It is true that many wild creatures react with fear in direct proportion to the number of humans about them. An oystercatcher patrolling a beach may allow a photographer to stand filming at a certain distance away. When a second person joins the first, the bird shows obvious signs of being nervous. The oystercatcher flies away the instant a third photographer comes onto the scene to join the others. Many mammals are even more conscious of being outnumbered. (We know from computerized records of bear attacks in recent times that bears are more likely to be aggressive toward one person than toward two or several grouped together.)

Then why do we advise joining a group? We are speaking here of camera club field trips, photography and nature clinics, ranger-led nature walks or canoe trips, bird viewing excursions, and environment and biology classes. The advantages of joining such groups are many, especially for newcomers to nature photography. Most are free or cost very little. Clubs are good places to meet kindred spirits, to exchange ideas, discover new equipment, and learn about new places to go.

Several of the 35SLR manufacturers (such as Nikon) hold regular camera/photography clinics, and these are ideal for understanding modern photographic equipment quickly and correctly. Some large companies in the Seattle and Portland areas (most notably REI) hold education seminars (including photographic) for employees and customers. Expert, well-known nature photographers often offer field courses in the summer at sites where photo opportunities are plentiful. At such meetings, an amateur can have his work critiqued on the spot and some mistakes corrected in a congenial atmosphere.

Nearly all of the federal conservation areas, the national parks, and wildlife refuges listed in Part 3 of this book offer hikes, lectures, or other events for the public, which can increase a photographer's skills. It is sound advice to take advantage of these and then go out on your own.

Nature walks and classes will certainly make anyone a better observer and wildlife spotter. A lot of interesting wildlife pictures can be credited as much to a keen spotter as to the photographer. We are fairly good spotters. Time and again we find creatures, especially birds missed by other hikers on the trail ahead of us. A sharp-eyed spotter is usually a product of much experience in the field, but also of being dedicated. In our case, we have been dedicated bird watchers for a long time. Both consciously and subconsciously, we are always looking for birds, and we keep detailed notes on what we see.

Watching birds anywhere is itself fascinating enough. But it is also a free, practical course in bird behavior. You learn where and when to look for lively photo subjects, where they nest and roost, and how they react to the presence of humans. Experienced bird watchers can identify species (from

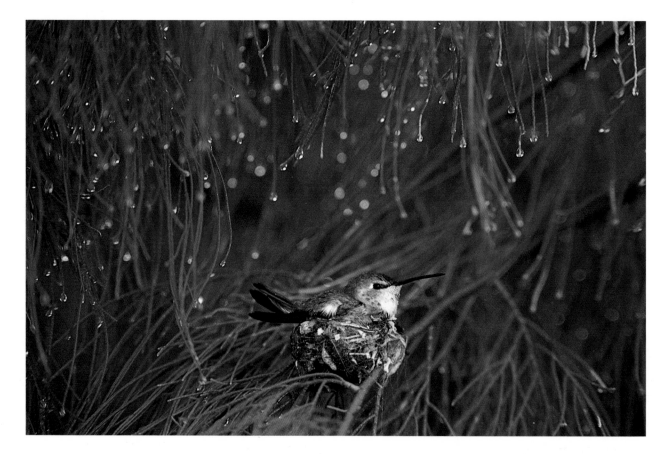

This Anna's hummingbird on a nest is protected from a steady drizzle, but not from being spotted by a keen bird watcher. This photograph was made with a 400mm telephoto lens and a 1.4X extender on a sturdy tripod.

unique field marks) quickly and positively without referring to a field guide. When you can do that you will also be much better at seeing the eye or slight flick of a deer's tail in a dark woods. Bird watching can make anyone a better observer.

A number of times, birds have actually called our attention to other creatures and to photographic opportunities. Where we live in northwestern Wyoming, great gray owls are resident but are seldom easy to find in their forest habitat. One of those we photographed was exposed to us by a Clark's nutcracker, which was molesting it. On other occasions we have been led to great horned owls by flocks of crows noisily tormenting them. Another time we were able to photograph a weasel that was being dive-bombed by a pair of hummingbirds. Probably the weasel had robbed their nest of the chicks.

By joining a group you can also take advantage of lower transportation costs to some distant places. Once there you can work on your own. There are a number of excellent lodges and outfitters in the West that cater to photographers, often offering favorable group rates. Some of the best of these are also listed in Part 3 of this book.

We spent a week at Old Squaw Lodge where the old (World War II) Canol Road crosses the Yukon-Northwest Territory border. It is a haunt of serious naturalists and wildlife photographers. We tramped many miles over spongy tundra and saw glorious sights. One morning it was overcast. While resting on a knoll, one of us noticed a small brown bird flying into the ground directly in front of us. We watched and quickly realized that it was a water pipit going to a nest it had concealed just between the permafrost and the thick layer of moss which insulates it. Without moving we were able to photograph the pipit sitting on its cool nest.

3
Where to Go

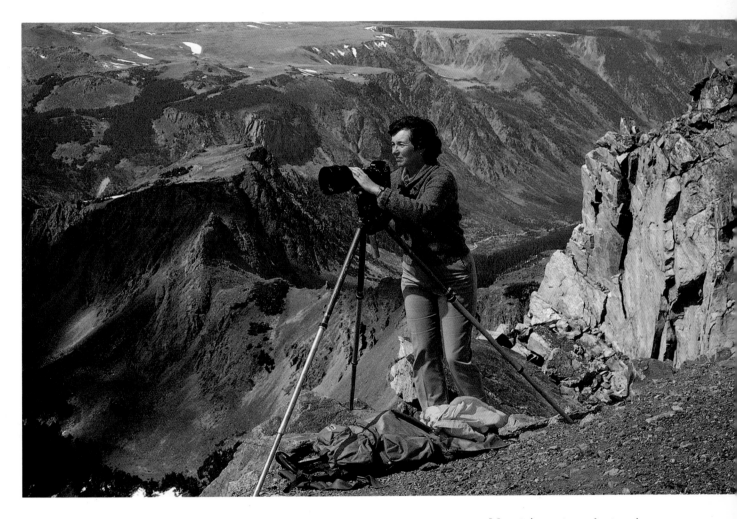

Mountain goats prefer terrain that few other creatures would wish to share. Here Peggy Bauer photographs them in the rugged mountains near the Beartooth Highway in western Montana.

◎ Northern California

There is good cause to crown California the state that originally held the greatest and most varied promise of any. Enormous trees—redwoods in the north, oaks farther south—rose unobstructed. Herds of game grazed the green meadows, and along the glittering Pacific, masses of marine mammals, schools of fish, and intertidal life lived in numbers and balance we can now only imagine. Intermittent waves of immigrants seeking wealth, adventure, or just a better life have made the Golden State now our most populous. Fortunately it is not also our most crowded. Although so much has been paved, plowed, and logged, there is much that has not. It is these precious areas that we discuss here. To conform to the scope of this book we will only consider those in the northern portion of the state.

National Parks

LASSEN VOLCANIC. The main feature of this, the least known and smallest of the national parks in California, is the devastated peak of Mount Lassen. Until the explosion of Mount Saint Helens in 1980, Lassen was the most recently active volcano in the contiguous forty-eight states. Less than one hundred miles east of Redding, Lassen contains, in addition to the peak, over one hundred thousand acres of evergreen forest and fifty wilderness lakes. From the thirty-mile road that arcs the peak's western slopes, the photographer can see and photograph cinder cones, lava beds, and other interesting textures and shapes that are the legacy of the eruption in 1915. Lassen Peak Trail leads to an overlook above small craters, forests, several lakes, and even Mount Shasta, seventy-five miles distant.

REDWOOD. The coastal redwoods and their cousins, the giant Sequoias, are the last surviving species of a large genus of geological times past. The redwoods are the tallest trees in the world and were once abundant along the California coast. Now only remnants remain in a protected strip of land, part national park and part California State parkland. The protected areas are divided in five sections along the far northern coast.

The best photographs convey the sense of timelessness and history of the looming trees. A wide-angle lens does this best, and a touch of color from any blossoms at ground level add to the beauty. For contrast, the photographer may wish to use his closeup lens for pictures of the almost absurdly tiny cones of the redwood; they are slightly smaller than a child's marble. The cones of the Sequoias are only the size of a small hen's egg. The light here is dim, so a slow shutter speed and/or a fast lens is required.

YOSEMITE. Many inspired, tireless men and women have championed the cause of this magnificent piece of American real estate east of San Francisco. The earliest was John Muir whose efforts to have the area designated a national park were successful nearly a century ago. More recently the

haunting photographs of Ansel Adams engendered appreciation of nature in general, and Yosemite in particular, to much of the world. The best known area is Yosemite Valley, which is bounded by massive granite cliffs over which tumble, flow, and drift snow-fed mountain streams. El Capitan, Half Dome, and Bridal Veil Falls have been photographed thousands of times, but are nonetheless as marvelous as they were when the first lenses were turned toward them.

Beyond the valley are 1,200 square miles encompassing five life zones. Visitors use the free shuttle bus within the valley and hike or drive elsewhere. Visit Mariposa Grove for the giant Sequoias (the most massive tree, if not the tallest, in the world), Glacier Point for the views, and Tuolumne Meadows, the largest subalpine meadow in the High Sierra. Eighty-nine percent of Yosemite is backcountry, and the park service has constructed 770 miles of trails, which are the best means to reach the most exquisite places. Most photographs made here will be scenics. No better example can be followed than that of Ansel Adams.

National Monuments

LAVA BEDS. Less than sixty miles from Klamath Falls, Oregon, and south of Tule Lake National Wildlife Refuge, Lava Beds consists largely of the cooled and hardened lava that spread over the land centuries ago. Volcanic activity has left cinder cones such as Schonchin Butte. There is a trail leading to the summit, and views of the surrounding landscape. Black Crater and Fleener Chimneys are classic examples of spatter cones. Most of the lava is the smooth pahoehoe type, but there is also a rougher texture as seen in Devil's Homestead Flow and Black Lava Flow. Lava tube caves honeycomb the area and nineteen are open for exploration. Flash photography is necessary in these. They are remarkably cool and damp, and the footing may be uncertain.

Although the difference in altitude between the highest and lowest points in the monument is small, there are three distinct plant associations: grassland-sagebrush, juniper-chaparral, and at the top, coniferous forest, mainly ponderosa pine. Wildlife consists of small rodents, coyotes, bobcats, and mule deer, which migrate in winter from Medicine Lake Highlands south of the park.

National Seashores

POINT REYES. Only thirty miles north of San Francisco, Point Reyes is a peninsula that reaches into the Pacific. It was designated a national seashore about twenty-five years ago, and while most of the land is in public ownership, some portions will remain dairy farms for years to come.

Narrow, wild coastal beaches are backed by steep bluffs. From the bluff edge California sea lions can often be seen on the sands below. Early morning hikers often see black-tailed and introduced fallow deer. Bear Valley Trailhead is a popular beginning point. Estero de Limantour and the surrounding mud flats are excellent places to see and, with patience, photograph shorebirds. During winter Abbotts Lagoon is full of wintering waterfowl. Murres winter at sea, but nest on rocky shores in summer. The best time to see wildflowers is from late February to late July. Weather influences the success of photography at Point Reyes. In summer the ocean

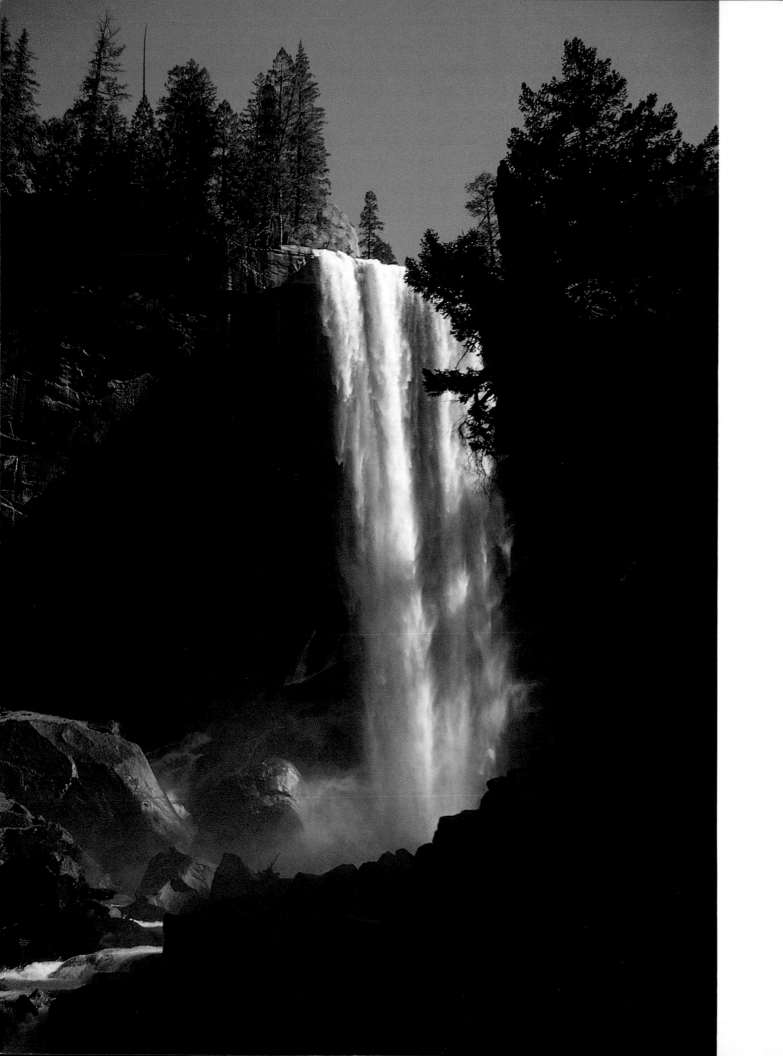

beaches (on the west) are often foggy, but sunny in spring and autumn. The east side (accessible by trail only) is free of fog in summer, but suffers from heavy rains in winter and spring.

NATIONAL WILDLIFE REFUGES

MODOC. The many lakes and ponds that are dotted with small islands make Modoc a wonderful habitat for birds. Showy sandhill cranes dance and nest, and satisfyingly large (and more easily photographed) white pelicans are here in spring and summer. The watery areas are surrounded by typical Great Basin landscape—flat sagebrush to the horizon. A fortunate photographer may see several hundred pronghorn antelope migrate at close range in March or November. Mule deer are common in the summer and Belding ground squirrels are everywhere, especially on the dike roads. Bald eagles sometimes roost in the cottonwood trees near refuge headquarters in winter. The refuge in the northeast corner of the state is least pleasant at this time of year.

CALIFORNIA STATE PARKS (ALONG THE COAST)

The state of California has declared all beaches below mean high tide as public property. The character of the shoreline changes from warm, benign beaches in the south to rugged, rocky coasts in the north. We will describe only the most outstanding of the northern parks here beginning with the more northerly and proceeding south to San Francisco.

REDWOOD STATE PARKS. The Save the Redwoods League's heroic efforts culminated in the setting aside of nine state parks along the shore. They are scattered from Henry Cowell south of San Francisco to Jedadiah Smith on the Oregon border. Meant originally to protect the great trees, they became the nucleus of the entire state park system. The huge trees dominate, but other flora, often flowering broad-leaved evergreens, share the habitat. The most rewarding for the photographer is Prairie Creek, a section of state-owned land that adjoins Redwood National Park south of Crescent City near the Oregon border. This section is outstanding since not only can the photographer focus on the redwoods with their surprisingly feathery foliage and tiny cones, but in addition Roosevelt elk are fairly easy to see and photograph. For best pictures of the tall spires use a wide-angle lens. Then with a smaller lens concentrate on the textured bark, the cones, and the wildflowers that may bloom in the gloomy understory.

PATRICK'S POINT. Patrick's Point is approximately thirty miles north of Eureka. The damp sea air from the Pacific moistens mighty trees, and waters the many species of broad-leaved evergreens that bloom each spring. Trails along bluffs overlook the rolling surf and narrow, dark beaches. Wooded points of land jut westward to make wonderful scenic photographs in bright sun or morning fog. Songs of the varied thrush and the twitter of small woodland birds fill the air. Some can be seen at eye level on the tree trunks picking for insects that live there.

MACKERRICHER. Mackerricher is a short drive north of Fort Bragg. A

The High Sierra trails of Yosemite National Park lead to some of the wildest scenes in the West. Typical of this is Vernal Falls (opposite), which is within easy hiking distance of Yosemite Valley.

short walk on a windy, level trail from the campground and parking area leads to a jumble of large dark wave-washed rocks, where spotted harbor seals lie in the sun. A slow approach with a long telephoto lens permits pictures of the creatures bobbing in the heaving swells of the Pacific. Other seals, a bit farther off on the rocks, are more successfully filmed. Look especially for light-colored individuals against the dark rock and be alert for those that undulate in a peculiar fashion from their resting place to the protection of the dark waters. Confiding mallards frequent the quiet ponds of the inland areas.

VAN DAMME. Near Mendocino, Van Damme State Park is well known for its Fern Canyon. The plants form an uninterrupted mat on the sheer, wet steep rock walls. Most numerous are the western sword fern, but look for others, too: the bird's foot, deer fern, and possibly the goldback. Visit Pygmy Forest where mature cone-bearing cypress and pine trees have reached their full height at only six inches to eight feet from the ground. The tide pools with marine plants and tiny sea creatures can be photographed at low tide. Wait until the wind stops ruffling the surface water to release the shutter, or use a clear Lucite panel as a windscreen.

SONOMA COAST. Just north of Bodega Bay stop on the west side turnout and look directly below on the narrow beach or in the water for harbor seals. A steep descent to the sea level and over a tumble of huge driftwood logs brings the photographer to within reasonable photographic distance of the sleek mammals. If the eels are running the seals catch one after the other near shore, often tossing their heads in the air in an effort to subdue their prey. Otherwise they lie like cordwood on the beaches little concerned by the presence of a photographer, who should approach slowly and cautiously.

STATE PARKS (INLAND)

CLEAR LAKE. Plants foreign to those that grow along the Pacific are prolific here about one hundred miles north of San Francisco. Western redbud, California buckeye, manzanita, and toyon, which produces red berries for the December holidays, beg to be filmed. Waterfowl, colorful in breeding plumage, gather in spring. Wonderfully bright wood ducks nest, and pelicans stretch their long necks and yawn with gaping, cavernous bills. Resident rodents include beavers, and there is an occasional bobcat, but neither is really photographable. Ground squirrels and black-tailed hares might be.

📷 OREGON

Oregon's well-known scenic beauty suits every taste. On the eastern border the Snake River has cut the deepest gorge in North America. Farther west lies a great desert. The Cascade Mountains rise in west central Oregon where the heavy rains nourish vast coniferous forests. The rocky, rugged coastal area has wisely been kept in public ownership avoiding tasteless commercialism and/or private residences that exclude the public from these magnificent vistas. Each area presents photographic possibilities. While some are of wildlife, most are scenic.

NATIONAL PARKS

CRATER LAKE. Crater Lake is approximately sixty-five miles northeast of Medford in the southwest quadrant of the state. Some roads close in winter, depending on the weather. One of the highest volcanic peaks of the Cascades, Mount Mazama, erupted ages ago leaving a great cavity that has since filled with water to form one of the deepest lakes in the world. A sonic depth finder has measured the lowest point at 1,932 feet. For this reason the lake waters do not freeze but remain sapphire blue throughout the year. The steep lakesides with towering conifers reflected in the water make superb photos at any time, but perhaps especially in winter when the dazzling white snow upholsters the boughs.

Wildflowers such as phlox, knotweed, and monkey-flowers are easily photographed in summer. Golden-mantled ground squirrels are everywhere and quite tame. Less common are mule deer and black bears. Even more elusive are coyotes, porcupines, bobcats, and red foxes. In winter be alert for martens that do not hibernate, but hunt squirrels, rabbits, and even birds. The dark, beautifully furred creatures are easy to spot against the white snow and may be found basking in the sun on a pine branch.

NATIONAL FORESTS

SISKIYOU—THE ROGUE RIVER. The Rogue River flows through the southwest corner of the state. Although mainly used for recreational (sport) fishing, this waterway, which has many access points through the national forest land, has something to offer the photographer, too. Trails along riverside cliffs lead to small streams that cascade into the turbulent waters of the Rogue. A great variety of birds wade the shallows and swoop and flit throughout the forest, but the only ones likely to pose for a prepared photographer are: great blue herons (usually from a long distance), dippers bobbing near shore, blue and ruffed grouse (especially during their spring courtship rituals), and perhaps a confiding pileated woodpecker. The mammals in the area include black-tailed deer and Roosevelt elk, black bears and river otters. None of these is really common or easy to see, but be alert for them and also for the rarely seen ringtail cat at the northernmost rim of its range.

SIUSLAW—CAPE PERPETUA. Cape Perpetua is approximately twenty-five miles north of Florence. Winds and waves lashing the shoreline for forty million years have hammered this coastal area into a place of bays, coves, and depressions wondrous to see. Seawater foams and whirls in Devils Churn and water forced through vents spouts like a whale. At low tide, focus a short lens on the creatures abandoned in shallow tide pools: starfish, sea urchins, sea anemones, and hermit crabs. Farther out at sea watch for gray whales and sea lions. Marked self-guiding trails follow the sea and lead through the spruce trees to an overlook. Wildlife in the area includes raccoons, black bears, and black-tailed deer, although the best photo opportunities exist beside the sea.

NATIONAL MONUMENTS

OREGON CAVES. The stalactites and stalagmites, and the flowstone in the shape of rippled sheets or frozen waterfalls in Oregon Caves, make offbeat

and interesting photographs. One really needs a tripod to do this justice, but they are not permitted in the caves. Flash photography with a hand-held camera must be substituted. Along the entrance road here in southwest Oregon, watch for black-tailed deer in the early morning and late evening. Near the cave entrance California ground squirrels, golden-mantled ground squirrels, and smaller Townsend chipmunks make appealing subjects. Common wildflowers include trillium, vanilla-leaf, redwood violet, and the tiny twinflower. For best results film these from a prone position.

NATIONAL RECREATION AREAS

HELLS CANYON. The Snake River, on its way to join the Columbia, has incised the narrowest and deepest gorge in North America at the eastern border of Oregon. Best photographs are of the solid rock walls that rise fifty-five hundred feet from the level of the river and are colored yellow, orange, and red. They can be filmed from a trail along the river or from a river-running boat. Look for bighorn sheep where Battle Creek joins Hells Canyon.

NATIONAL WILDLIFE REFUGES

HART MOUNTAIN NATIONAL ANTELOPE RANGE. Pronghorn antelope are not reliable camera subjects because they migrate unpredictably over a vast area. At times they are even in the neighboring state. They just may be near refuge headquarters early and late in the day except in midwinter. Mule deer, bighorn sheep, coyotes, and yellow-bellied marmots also live on the refuge, but better stars for the film are the sage grouse in their strutting courtship ritual from mid-March to mid-April. Fast film and a fast lens are necessary because the birds perform before the sun is fully risen. The nearby Warner Valley has many lakes where large numbers of water birds stop on migration. Some also nest here including white pelicans, sandhill cranes, and egrets. Wild horses, as everywhere, displace the native species and destroy the range for all.

KLAMATH BASIN. Because the four refuges in the Klamath basin are grouped geographically, we will consider them here as a single unit although they are in both south central Oregon and northern California. We have omitted Bear Valley and Clear Lake refuges because they do not present good photo opportunities.

Klamath Forest Refuge is mostly a large natural marsh that is an important nesting and migration area for waterfowl. It is best visited in July and August. Look for sandhill cranes on the north end, red-necked grebes beside the road on the east side, and white pelicans on Wocus Bay.

The only way to view the water birds on Upper Klamath Lake is by boats that can be rented. The birds include pelicans, herons, and egrets. Most of the marsh is closed to the public during the nesting season. An exception is the self-guided canoe trail and another is the open water of Pelican Bay and several creeks. With luck bald eagles and ospreys can be seen fishing in refuge waters.

Lower Klamath Lake and Tule Lake (both in California) are the scene of probably the most noteworthy migration spectacle in the United States. Each year in October and November 80 percent of the world's population of

Ross's geese are only part of the millions of birds that pass through. One-quarter million snow geese can be seen at once. Early in the morning and again late in the evening, twenty to fifty thousand birds move to and from the feeding grounds. These can be photographed with Mount Shasta as a beautiful background. Hawks, owls, and the largest concentration of bald eagles (about five hundred) outside Alaska gather in autumn to feed on waterfowl too weak to join their fellows in migration. Many eagles spend the winter. Look for coyotes and deer. Spring migrations bring birds too, but they arrive in smaller numbers. Canada geese and other water birds occasionally nest near the dike road. These make good camera subjects, especially when the fluffy young emerge from the eggs.

MALHEUR. The diverse wildlife of Malheur is best seen by driving the tour road. The six-week-long spring migration beginning in late February provides better photo opportunities than during the fall when the birds tend to gather on Malheur Lake, which is inaccessible. In recent years unusually heavy rains have covered the sagebrush flats and many of the roads have been raised and/or rerouted. This same high water has moved some of the birds closer to the road making them easier to photograph. Lesser sandhill cranes, snow geese, and many waterfowl species are especially easy to see. No foot traffic is permitted during the nesting season. Each year in mid-April the local Rotary Club sponsors the John Scharff Migratory Waterfowl Festival with guided bus tours of the area and special trips to the sage grouse strutting grounds. This is a good way for the unfamiliar photographer to orient himself. Over two hundred bird species are expected, although most will not be photographable because they are too distant. Visitors should phone ahead for reservations to stay at the Malheur Field Station at any time (503/493-2629). Meals are also served.

UMATILLA. The building of the John Day Dam on the Columbia River destroyed so much wildlife habitat that this refuge stretching twenty miles on each side of the river was established to help compensate for the loss. Six other small parcels in the vicinity also have been set aside. The waters never freeze and may be the most important waterfowl wintering area in the West. Of the three hundred thousand birds that stop, a great many are Canada geese. Hundreds of long-billed curlews arrive in early spring and remain on the nests until June. Eagles perch on the crowns of drowned trees, feeding on weakened and dead waterfowl. Watch for long-legged burrowing owls on loose earth, and for great blue herons and double-crested cormorants that nest on the river islands. Larger inhabitants are coyote, deer, badger, and beaver.

OTHER WILDLIFE AREAS

CRANE PRAIRIE. The largest concentration of nesting ospreys in the West arrive at the Crane Prairie Reservoir in early April. The boat launching area on the Quinn River, southwest of Bend, is a good spot for viewing, or navigate a craft to within telephoto lens range. Elk and deer can be seen in early spring and eagles nest to the south on Wickiup Reservoir. Sandhill cranes and great blue herons nest here, too.

JEWELL MEADOWS. Sixteen thousand elk are the photographic attraction in this location northwest of Portland. In summer only several dozen graze

beside the road, but in winter there may be 150. The fall rutting season is the most exciting time to come. The bugles of the bulls echo over the hills and occasional fights break out within sight of the parking area. Elk graze mainly in late afternoons (and at night) and are occasionally joined by deer. Coyotes also can be seen. They are rarely able to catch an elk calf, but do feed on mice. It is not impossible to see a bobcat, but highly unlikely.

THE OREGON COAST. Magnificent U.S. 101 parallels the Pacific Coast with spectacular seascapes everywhere. Any visitor on the road must wonder why every state has not preserved its natural beauty for the enjoyment of all as has Oregon. Visitors can see shorebirds on sandy or muddy tidal flats and herons in the lagoons. Eagles and ospreys perch in snags and are particularly plentiful at Oregon Dunes near Florence, about halfway up the coast. Marine Gardens Ocean Shore Preserve at Devils Punchbowl north of Newport, and Tidepool Preserve at Cape Perpetua (mentioned earlier) are especially rewarding for their intertidal life. Stellar sea lions can be seen and photographed on the mainland at Sea Lion Caves, a commercial preserve open to the public. This is also a good opportunity to photograph breeding Brandt's cormorants. At this time they have blue and buff throats. Inky black pigeon guillemots with crimson-lined bills and scarlet feet will pose for photographers. Use a long telephoto lens.

SAUVIE ISLAND. Sauvie is a large island in the Columbia River just north of Portland city limits. Each fall over fifty thousand waterfowl leave the north end to spend the night in Washington on the far side of the river. Be ready for them as they cross Rentenaar Road. During fall and spring thousands of sandhill cranes feed between Reeder Road and Sturgeon Lake. Oak Island is where three to four thousand whistling swans spend the winter.

WHITE RIVER WILDLIFE AREA. Approximately thirty-five miles south of The Dalles, thousands of deer are fed each winter by the Oregon Department of Fish and Wildlife. Ninety percent of these are black-tailed; the remainder are mule deer. Elk also congregate for the free handout. Wild turkeys can be seen outside the management area near Pine Grove.

WILLAMETTE VALLEY. Between Salem and Eugene, near the banks of the Willamette River, are five wildlife areas. Dusky Canada geese winter in Baskett Slough National Wildlife Refuge and can be seen from a county road. A trail along Bashaw Creek in Ankeny National Wildlife Refuge is good for small birds in summer, but is closed in winter. Exotic ring-necked pheasants and chukar partridges are raised at Wilson Wildlife Area where there is also a fawn orphanage. A few Taverner's Canada geese and nine thousand dusky Canada geese use the William L. Finley National Wildlife Refuge. None of the birds is easy to photograph, but the best opportunities occur in fall.

OTHER AREAS

OREGON HIGH DESERT MUSEUM. Seven miles south of Bend, this wonderful little museum offers an education on the wildlife, land, and people of the area. Inside is a small naturalized exhibit featuring tiny live owls. Outside there are streams, a pond, and nature trails where photography is easy, and the animals are accustomed to human intrusion. Naturalistic en-

closures make photographing porcupines and river otters easy, especially when they are being fed by staff. Field trips offer other photo opportunities. There is a small admission fee, and membership is encouraged.

WASHINGTON PARK ZOO (PORTLAND). Although some exhibits are depressingly unnatural, two others make a visit to this zoo worthwhile.

The Tundra area displays musk-oxen grazing as they do in the wild beside a natural-looking pond. Wolves, looking wonderfully wild, roam a bluff backed by a screen of trees that nicely obscures the fence behind. Tiny lemmings, snowy owls, and waterfowl are also photographable. But best are a lively pair of grizzly bears that often put on an exciting show splashing in a pool and wrestling with each other on the grassy slopes in full view.

The other area is the Cascades Stream and Pond Building, which contains plants and animals found west of the Cascades. Look for large rainbow trout, best photographed when they drift into a beam of sunlight. Another fine subject is the dipper, which can be photographed at close range. In addition there is a river otter display and a display containing waterfowl.

WASHINGTON

To the wildlife and outdoor photographer, the state of Washington ranks among the top areas of interest. One of the world's great mountain ranges, the Cascades, divides the state east and west into two distinct regions. This range marches from Canada's Fraser River through all of Washington and extends southward even beyond Oregon's southern border. It determines the climate and vegetation over much of the Pacific Northwest. The western shoulders intercept the moist prevailing winds, and the resulting precipitation produces the soaring evergreen forests, deep lingering snowfields, and watercourses from tinkling rivulets to burly rivers. On the east slopes, with most of the moisture removed, the climate becomes progressively drier and warmer. The landscape is transformed from green meadows to coniferous forests and finally to dry shrublands.

In the continental United States there are eleven hundred glaciers covering 205 square miles. The state of Washington has eight hundred glaciers covering 160 square miles; obviously far more than its share.

The far northwest corner, the Olympic Peninsula, is the site of Olympic National Park. The park and all parts of the peninsula that surround it are well worth the photographer's time and attention. The wild, wet terrain contains some of the most magnificent shorelines in America, lush vegetation, and plentiful wildlife.

Finding the major scenic areas in Washington is easy when following U.S. highway routes. But highway signs and directions are often confusing and not infrequently missing altogether on the Washington State network. A good sense of direction is invaluable to the visitor.

NATIONAL PARKS

NORTH CASCADES. The North Cascades is one of those treasures where the photographer can find both magnificent scenery and photographable

wildlife. The newest and wildest of the Northwest parks, it is traversed by a single highway, State Highway 20, which runs ninety miles east and west. It is closed in winter. Beside the route and extending northward along the eastern boundary is Ross Lake National Recreation Area. Lake Chelan National Recreation Area is at the southern tip. Within the two recreation areas and the park are alpine scenes of icy glaciers, rough peaks, canyons, lakes and streams. The tough granite has been gouged by ice and rock to knife-edged ridges blanketed in snow and ice well into summer. Lake Chelan fills a glacial trough eighty-five-hundred feet deep from its bottom to the valley crest. It is one of the continent's deepest gorges. The eastern side of the park is drier and noticeably warmer at all seasons. The progression from waterfalls and ice caps on the west through subalpine conifers, tundra, pine, and finally to arid scrub on the east side occurs within a remarkably short distance.

Photography from the road is better for the wildlife that may be encountered than for scenes that are hidden behind a nearby high ridge.

Along the road on the west side of the park, beside the Skagit River, bald eagles spend the winter feeding on the salmon that have spawned and died there. Also in winter, you may view the mountain goats that come down to the lower elevations to feed along the slopes of Lake Chelan. They are best observed from a boat on the lake. At other seasons boat rides on Ross Lake offer views of the snow-covered peaks reflected in the water and picturesque confluences with the creeks that feed the lake along the route.

But the best way to explore North Cascades National Park is to hike the trails. Early in the day is best; the low light illuminates textures that disappear as the sun rises high, and the animals are more active and visible at this time. The trails will be less populated at this time as well. Watch for deer in the meadows. You may find spotted fawns browsing beside the does by midsummer, and bucks seeking female companionship in the late fall. Be on the lookout for black bears. Wildflowers bloom at ever higher elevations as the season progresses. At each rockslide area listen and then look for the pika, a miniature, round-eared short-legged relative of the rabbit. Pikas have the interesting habit of collecting large piles of vegetation throughout the summer, which they turn to cure in the sun before storing beneath the rocks for winter use. The much larger rodent that whistles an alarm before you see it is the hoary marmot. These can often be approached quite closely with slow movements, quiet voices, and much patience.

Also present in the park, but unlikely to be seen are the cougar, wolverine, marten, and fisher.

OLYMPIC. Olympic National Park consists of beaches, deep forested valleys, and high mountain ridges. More rain falls on the lower slopes of the Olympic Mountains than on any other part of the lower forty-eight. The summer months are the driest and most pleasant times to visit, but the Roosevelt elk leave the accessible areas during this season and wander the high elevations.

Cedar, hemlock, spruce, and fir crowd the mountainsides. Ferns, mosses, and fungi carpet the forest's floor. The slopes leading to the snowy peaks are covered with wildflowers from late June until October, and wildlife is often abundant and easy to photograph.

The most rewarding route for the photographer is Heart of the Hills Road, an eighteen-mile ascent that runs from the northern park boundary near Port Angeles to Hurricane Ridge. About halfway up there is a won-

derful view of Juan de Fuca Strait, and in each forest opening wildflowers bloom. At the ridge subalpine larkspur, American bistort, and fan-leaf cinquefoil grow so close together that a single footfall would crush several plants. Some plants are endemic to the Olympics; of these the best known is Piper's bluebell. Black-tailed deer are often found here and some are especially confiding and nicely photographed against the flowered background. Honey-brown Olympic marmots (lighter colored than those in the Cascades) burrow near the trails. A photographer who sits quietly for a short while is accepted by the creatures who soon go about their business providing outstanding opportunities for intimate photographs. The young scamper and tumble together at the burrow's entrance, and adults sit straight as flagpoles, glossy coats shining in the sun. Black bears live in the mountains and can be seen grazing on the meadows.

Beautiful Lake Crescent, like Hurricane Ridge, lies on the north side of the park. U.S. 101 follows the south shore and in late spring you can sometimes photograph mallard ducks from here. Marymere Falls, a short walk from the Storm King Visitor's Center, is another scenic area.

Ruby Beach is a narrow strip of land on the west side (actually in the Hoh Indian Reservation). This is the place to photograph seascapes with seastacks and sea arches above glistening wet sand, sometimes cloaked by clouds of fog.

The Quinault, Queets, and Hoh valleys are typical rain forest. The bigleaf maple predominates, and they are often draped by air plants such as licorice fern and club moss.

Marine wildlife such as gray whales and humpback whales swim offshore during their migrations but do not make good picture subjects. Steller sea lions bark from offshore rocks and harbor seals occasionally raise their heads to observe beachcombers who are watching them.

Almost half the birds in Olympic Park are shorebirds, seabirds, and waterfowl. Small forest birds are easy to see but difficult to photograph without specialized equipment. Easier are the blue grouse that appear at the edge of the forested areas.

Anyone who has visited Olympic Park in the past will seek the numerous mountain goats they photographed with such enjoyment. They are still here, but are fewer in number. The animals, not native to the area, proliferated and caused increasing harm to the environment. Well over two hundred were captured and relocated, but approximately one thousand remain and can be found in the higher areas in the eastern part of the park. More, perhaps two hundred individuals, are outside the park's eastern boundary in Olympic National Forest. An environmental assessment statement is being drawn up and public meetings held in early spring 1987 discussed the future long-term management of the mountain goats.

MOUNT RAINIER. It would seem that the single item of interest in this park, which is less than one hundred miles southeast of Tacoma, would be the peak itself. In fact this 14,410-foot volcanic mountain, visible for hundreds of miles, is a remarkable sight. Its massive capping glacier divides itself into forty-one individual arms. But there is more: there are blankets of wildflowers for the small lenses, and numerous species of wildlife for the longer ones.

Summer is the best time to visit Rainier, and here summer comes late. The best, easiest-to-reach place from which to photograph the mountain and Emmons Glacier is Sunrise on the northeast flank. Mount Rainier is the star attraction, but in addition there is a parade of neighboring volcanic

peaks that are also worth a generous length of film. Mount Baker and Glacier Peak rise on the north, and Mount Adams is on the south.

The line between winter (the lower edge of the snow) and spring (just below that) is always clear and it advances in altitude as the season wears on. Spring arrives in April at the lowest elevations, but does not come until late August or later at tree line.

There are a lot of open subalpine meadows in the park, making the wildlife comparatively easy to see and photograph. Concentrate on the hoary marmots—furry rodents slightly larger than a full-grown house cat. They are plentiful. After an initial pause when the photographer arrives, they will return to their duties quite unconscious of camera lenses held by quiet, steady hands. Pikas live in rocky avalanche habitats. Although they take more luck and patience to photograph than the marmots, they are generally considered adorable and worth the extra effort.

Golden-mantled ground squirrels and yellow pine chipmunks roam the picnic areas and forage in the high meadows. Most deer are blacktails, although mule deer are found in the east. The deer, often seen with twin fawns in early summer, graze in the alpine meadows and can be seen in the vicinity of Nisqually entrance station. They move to dense forests in autumn.

The easiest place to see mountain goats is near Paradise. Take a short hike to Van Trump Park. There are also some on the heights of Emerald Ridge, the Colonnades, beyond the West Side Road, and the Cowlitz Chimneys, on the east side of the park.

Ohanapecosh at the southeast corner is the place to see typical Washington forest along a fast-moving river. The Grove of the Patriarchs is comprised of trees nearly one thousand years old. Not far is Silver Falls.

Steep trails lead four miles to Cowlitz Divide where elk (some think far too many elk) are flourishing. Shriner Peak to the east is also a likely area for elk. Bulls are easier to see during the fall rut when their calliope call rings throughout the land. In winter they move outside the park.

Black bears wander anywhere and, contrary to general belief, do not truly hibernate, but make wake up during the winter to venture forth for a few hours or a few days. They feed on grasses early in the season (look for them in open meadows) and on berries in the fall together with whatever presents itself as appetizing. (Remember to keep your distance from these bears.) Coyotes also wander where they choose and do so all year long. Raccoons and striped and spotted skunks range in the lower elevations but are probably not the most rewarding creatures for the photographer in Mount Rainier National Park.

NATIONAL FORESTS

OKANOGAN. On State Highway 20, just east of North Cascades National Park in the Okanogan National Forest, are three stopping places for scenic photographs. The highest point on the highway (5,480 feet) is Washington Pass. From here a short road leads to a parking and picnic area and from there follow a loop trail a short distance to the overlook. The spectacular view looks down on Early Winters Creek to the peaks of Silver Star Mountain and Snagtooth Ridge, to Cooper Basin, and finally to Liberty Bell Mountain.

A bit farther to the west, Blue Lake lies in a rock-walled basin. It is a steep 2.2-mile hike past silver and dark green alpine scenery to the beautiful mountain lake. As in most places in this area, waterproof footgear increases enjoyment.

Because of the fog and mist of the region, Redwoods National Park can be a difficult place to photograph, especially if not enough time is allotted. Our photograph of a weak shaft of sunlight behind a fallen giant more or less typifies the haunting atmosphere.

When fog obscures the landscapes of Point Reyes National Seashore, a photographer can turn to smaller subjects. We photographed the brown garden snail on a cobweb thistle.

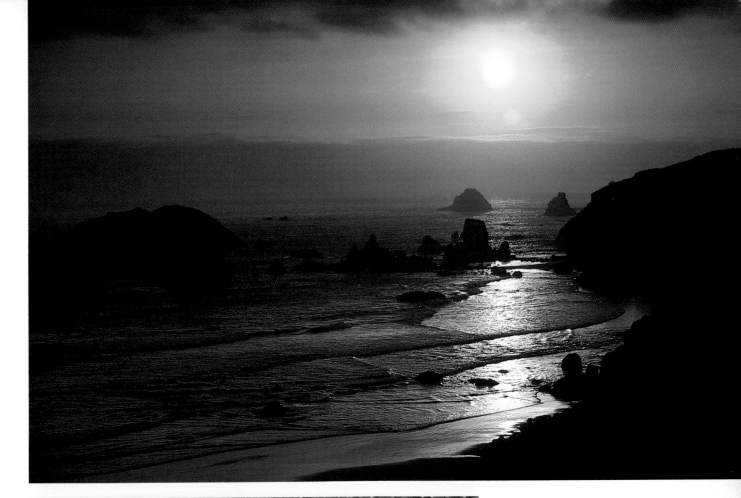

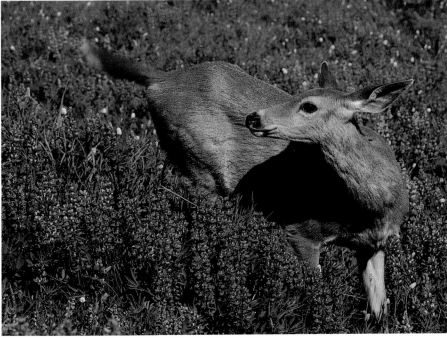

For almost its entire length, the Oregon coast is a magnificent littoral. Fortunately most of it is also accessible to the public. Dramatic seascapes are shot early in the morning and just before sunset.

Wildlife photographs are always enhanced by attractive environments. We watched and followed this black-tailed doe in the North Cascades until she reached a meadow of lupine. Then we exposed plenty of film on a fairly confiding subject.

Skunk cabbage (opposite), which appears early in the season, grows in moist places in western Oregon. Black bears can often be found feeding where skunk cabbage grows in profusion.

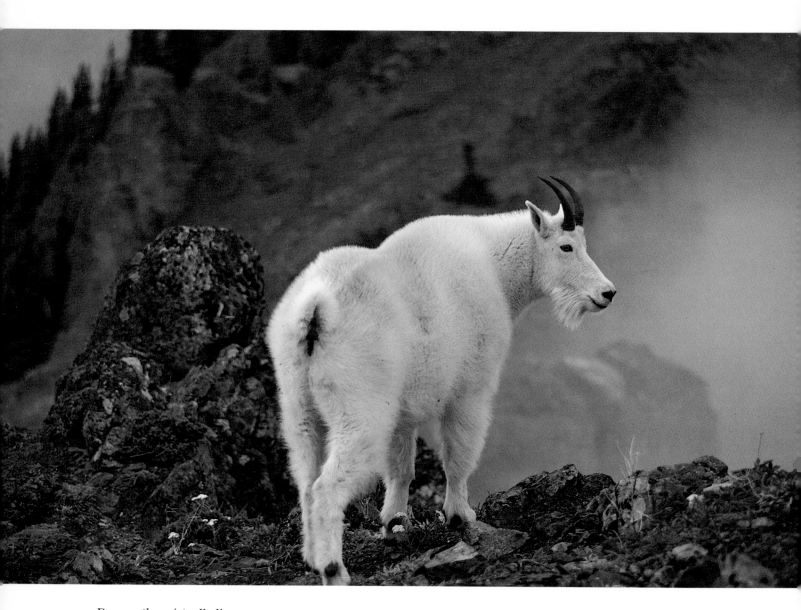

Because they virtually live on top of Washington, mountain goats are the most challenging of big game to photograph. Once you reach their level, they may not prove as shy as some other animals.

Lake Ann is an even more lovely destination. Not far west of Blue Lake, along the Pacific Crest National Scenic Trail, it is a two-mile climb edged in summer by the many moisture-loving wildflowers of the area: white marsh marigold, anemone, and glacier lilies. As you gain altitude and approach the lake, the evergreens show evidence of great winter suffering. The stunted, bent, and knotted trunks make interesting photographs. Watch for pikas on the avalanche slopes.

NATIONAL WILDLIFE REFUGES

DUNGENESS. Dungeness is a fortunate meeting place of a number of different habitats. Mainly a long (five and a half miles) thin finger of sand, it also encompasses an area of coast on the northern shore of the Olympic Peninsula backed by steep bluffs and a forest of hemlock, cedar, and fir.

High above the spit, take the closeup lens and walk beneath the forest canopy seeking starflowers and the several orchid species including the Calypso. Easier to find are the Indian paintbrush, Nutka rose, and thimbleberry. Dune wildflowers include yellow sand verbena, purple-blossomed beach pea, and a daisy called gumweed. Glasswort grows on mud beaches and tidal lagoons. Low sun on the dunes, windrows of kelp, and driftwood make good photo studies, too.

The refuge was created to protect the eelgrass beds that nourish the black brant geese. The brants, small dark geese with white collars, do indeed feed during migrations (more in spring than fall), but they are shy and difficult to photograph.

The marine environment along the wave-lashed outer shore favors the loons, grebes, and other birds that live on small fish. Shorebirds that consume intertidal organisms such as dunlins, sanderlings, and plovers forage on the sheltered inner shore and mud flats. Cormorants perch on pilings, spreading their wings to dry.

Harbor and elephant seals often bask on the spit sands but are difficult to approach. Black-tailed deer frequent the forest early and late in the day. Occasionally red fox and river or sea otters become visible in the area.

The Dungeness area is in a rain shadow and therefore often pleasantly warm and sunny when surrounding lands are dull and wet.

NISQUALLY. This refuge, surrounded by two million persons living in and around Olympia and Tacoma, nonetheless seems to have something for everyone. There are both freshwater and saltwater areas, and both land and sea mammals. Marine creatures cruise offshore but are nearly impossible to photograph. On land things go better: there are foxes, mountain beavers, black-tailed deer, and coyotes. Seabirds plus two species of loons, two of geese, and four of grebes are most abundant. Upland trails traverse the habitat of California quail and pheasants. Numberless shorebirds and ducks stop during migrations and several species of gulls are here year-round.

Be sure to dress for the cool, rainy climate and make provision to protect camera equipment from moisture.

RIDGEFIELD. Thousands of waterfowl visit Ridgefield, north of Vancouver,

Washington, during migrations. These include the seldom-seen dusky Canada goose. Great horned owls are common along Bower Slough and sandhill cranes often stop in spring and summer. Several hundred great blue herons, usually skittish and difficult to photograph, nest just off the refuge. Snipe often sit atop fence posts, and pose for passing photographers. There are tundra swans (formerly called whistling swans) as well. Black-tailed deer are fairly abundant. Look for beaver and nutria. Drive the refuge road or walk Oak Grove Trail.

SAN JUAN ISLANDS. These islands are the tips of eighty-four submerged mountains of the Olympic range. Some are part of the national wildlife refuge system. View seals, otters, and killer whales (orca) from boat (ferry, rented, guided, or personal). Water birds feed in the tidal rips. These present the usual problems of boat photography: moisture, unsteady footing, undulation, and elusive subjects. A visit to San Juan Island's southern tip is interesting for the two foreign creatures here: the Eurasian skylark and the colonial European rabbit that thrives in spite of predation by golden and bald eagles. Ospreys, too, often perch on snags. The San Juan Islands, like Dungeness, are in the rain shadow. This is a respite from what in Washington are often gray, damp adventures.

WILLAPA. Divided in three parts, this refuge in the southwest corner of the state, is home to a variety of wildlife. The far northern section, Ledbetter Point, is the least rewarding. The mainland area with miles of dikes around sloughs and freshwater marshes is the place to see scoters, old-squaws, and occasional harlequin ducks. Best of the three is Long Island with meadow, marsh, and forest, where the densest black bear population in western Washington lives. Here too are the Roosevelt elk, coyotes, beavers, otters, and black-tailed deer. The best time of year at Willapa is spring and fall during the bird migrations. Only foot traffic is permitted. Winter brings deluges of rain.

NATIONAL ESTUARINE SANCTUARY

PADILLA BAY. Padilla Bay is one of the largest relatively undisturbed tide-flat areas in Puget Sound. Its 11,600 acres protect tidelands and a wildlife habitat area accessible by eight miles of nature trails. The beds of eelgrass are strategically located on the migration route of the brant and forty-eight thousand stop in spring. Fewer pause in fall, but five thousand may winter here. The birds are difficult to photograph as they rarely come ashore, preferring to float in large flocks on the open sea even during storms. Look for them in the water near the Breazeale Interpretive Center and farther out toward Samish Island. Masses of dabbling ducks and dunlins and western sandpipers also frequent the bay. A large rookery of great blue herons is on Samish Island (the most seaward point of the area). As many as seventy harbor seals have been counted on the sandy and muddy flats and tidal channels in the southern portion of the bay. On higher, drier ground there are coyotes, raccoons, and black-tailed deer.

Padilla Bay attracts many visitors. If you arrive early when the light is best, you will have a better chance at good photographs.

STATE WILDLIFE RECREATION AREAS

MARBLEMOUNT EAGLE SANCTUARY. Just west of North Cascades National Park, between Concrete and Marblemount, large groups of bald eagles gather at this sanctuary between mid-December and mid-February to gorge on the salmon that have spawned and died. This is the best place in Washington to see them. Drive State Highway 20 along the north side of the Skagit River and look across to the south side of the watercourse. It is best to take photographs from the vehicle window using the longest possible lens. The weather is generally dreadful but this means that the birds are less likely to be soaring high and out of camera range, and more apt to be sitting quietly on trees where the photographer can use the necessarily slow shutter speed the gloomy climate calls for.

SINLAHEKIN. Sinlahekin is located in north-central Washington east of the Pasayten Wilderness Area. The best time to visit here is deep in winter when the deer from the area are driven to the valley floor (where the road is) by the snows that cover their summer range. Bighorn sheep that were transplanted here from California after the original herd was decimated are also occasionally down at the lower elevations. The most easily seen are groups of ewes and lambs. The rams remain high until the fall breeding season.

SKAGIT. Here the Skagit and Stillaguamish rivers empty into Puget Sound—but not quickly. En route they slow and meander across tidal flats, only gradually mixing with salt water. These rich, wet acres are vital grounds for water birds. The birdlife here is very similar to that at Padilla Bay not far to the north, but in addition Skagit beckons large flocks of tundra swans and clouds of snow geese. Look for them on the flats and also in adjacent farmers' fields where they graze.

OTHER AREAS

NORTHWEST TREK WILDLIFE PARK. Part of the Metropolitan Park District of Tacoma, Northwest Trek is in Eatonville, thirty-five miles from Tacoma. It is the photographer's best opportunity in the state to find and photograph all of the wildlife indigenous to the area. All animals are present at all times, and all are photographable in natural surroundings. Black bears, wolves, badgers, river otters, bald eagles, and wandering deer are only a few. A forty-five-minute tram ride conducted by a park naturalist through the "free roaming" area is a good opportunity to see bison, bighorn sheep, pronghorns, moose, and deer. The park is open daily except during winter when it is open only weekends or holidays.

OLYMPIC GAME FARM. Follow the signs from Sequim, on the north side of the Olympic Peninsula to the Olympic Game Farm. Here you can drive your own vehicle on roads that wind past photographable animals from around the world. Flocks of Canada geese are reluctant to move from the route. Some animals, not suitable for roaming, are caged, and it is often possible to make portraits, taking care to eliminate signs of wires and their

shadows. But the free-roaming elk, bears (both black and grizzly) retained only by a thin strand of electrified fence, African animals, such as zebras and white rhinoceros, plus several species of exotic deer make the trip one of the most worthwhile on the Pacific Coast. Weekends are busy. If you relish solitude, come during the week and early in the day.

PORT ANGELES HARBOR. Many of the same water birds found at Dungeness National Wildlife Refuge are also in Port Angeles Harbor a few miles west of the refuge. With the presence of fishing boats and the traffic of residents attending their crab and shrimp pots, the birds are more habituated to people and more approachable than at the refuge. There are loons, grebes, cormorants, mergansers, and shorebirds. All look their lustrous best in breeding plumage that shows first in early March. Pelagic cormorants breed here and nest on pilings near shore. Seals haul out on floating logs. This is directly on the Pacific flyway, and during the April and May migrations vast numbers of birds pause on their journeys.

WOODLAND PARK ZOO (SEATTLE). In addition to the usual creatures of a zoo, the photographer should make a special effort to visit the marsh and swamp exhibit. This three-quarter-acre area has been transformed to an authentic-looking New England swamp and marsh. Trees, wildflowers, and shrubs plus pond water blackened to resemble old ponds rich in humus are home to birds and aquatic creatures native to the East. The patient and alert observer will eventually find nearly invisible bitterns, shy sora rails, and many varieties of ducks and Canada geese. Many nest and raise families here; a few are truly wild and are admitted to the enclosed area in spring, then released in fall to fly away. Bullfrogs, crayfish, and pond turtles are not protected from predation and live a life as perilous as they would in the wild. Smaller subjects are present for macrophotography such as insects and the classic spider webs festooned with early morning dew drops.

Other projects, planned or completed, are the Alaska exhibit, an Asian elephant forest modeled after a Thai logging camp, and both a tundra zone and temperate rain forest project. For the nature photographer, these areas are the next best thing to being there; perhaps in many ways, better. The animals are accustomed to human visitors, so you may tour at your convenience without the bother and expense of overseas travel, and civil disturbances should be few.

WOLF HAVEN. Although wolves can be seen in several other places, Wolf Haven is the only sanctuary west of the Mississippi River that is set aside especially for this species.

The large natural enclosures make photography of the several subspecies easier than in most other areas. The white wolf pair atop a grassy rise are favorites. In addition to the wolves, there are a few arctic foxes and coyotes.

From June through September, the sanctuary is open daily (with "howl-ins" each Friday evening at 7:00 P.M.); from October through May, it is open on weekends only.

Wolf Haven is in Tenino on Offut Lake Road, off Old Highway 99.

For anyone planning to drive in Washington (or the greater Northwest area) a new large, paperback book is available, NORTHWEST MILEPOSTS®. This follows the very successful format of THE MILEPOST® that so many

Alaskan visitors know. It describes attractions and accommodations along each of the major highways and also covers islands, major cities, and even the national parks. It is available from book shops or from Alaska Northwest Publishing Co., 130 Second Ave. So., Edmonds, WA 98020.

◉ IDAHO

Large regions of Idaho are only rarely visited, although they abound with scenic beauty that rivals any in the Northwest: jagged mountains, endless acres of sagebrush flats that shimmer in the noonday sun, and forests that are green year-round. Views from the Salmon River are unsurpassed. Coal black lava flows, only recently extruded, cover large areas and are punctuated with tough pioneer plants. Wildflowers, game, and birds come and go with the seasons. Justly called the Gem State, Idaho may indeed be a treasure as yet imperfectly perceived.

NATIONAL MONUMENTS

CRATERS OF THE MOON. Recently (as these things are measured), molten lava oozed and gushed from the earth washing over much of southeast Idaho. It solidified as motionless waves, ripples, and perfect cones of cinder. Shallow caves were formed, and today they can be explored, their grim mouths hollow and dull black. Entire trees were pushed over by the relentless movement of the lava and then buried beneath the flow. The trees have disappeared, but the perfect molds remain. Bright wildflowers such as golden blazing stars that seem too delicate to find life here make wonderful subjects for photography. The monument, near Arco, is northwest of Pocatello, and best visited in spring or early summer when the few scattered trees produce lime green leaves that often seem luminous against the black velvet lava.

BUREAU OF LAND MANAGEMENT AREA

BIRDS OF PREY NATURAL AREA. A fortunate combination of factors have made this area, which is located near Boise, the site of the largest concentration of raptors in North America. The friable soil has been cut by the Snake River, which flows in a deep chasm far below the level of the surrounding featureless plain. Golden eagles, prairie falcons, red-tailed hawks, and many others find ideal nesting platforms on the rough canyon walls where they are safe from predators. On each side of the river a large population of Townsend ground squirrels conveniently emerge from winter burrows just as the raptors arrive in spring. The young ground squirrels are available as the nestlings begin to need them. The adult birds effortlessly rise on warm thermals, catch a ground squirrel meal, and drift downward to the hungry chicks.

Access to the area, on the Snake River about fifteen miles due south of Nampa, is unrestricted, and one can travel on the dirt roads throughout the area. Some nests can be photographed with the longest available lenses

supported by a tripod. Care must be taken not to approach so close that the parent birds are disturbed. Birds flying overhead are best photographed by hand-held cameras, and this may be the best use to which an automatic focus camera can be put. It is possible to float the river in one's own craft or to hire one locally. Floating the river, however, is better for watching the activity than for photography, because the birds are too far away to photograph. There are no facilities for the public here, but visitors can overnight in either Nampa or Boise.

Other desert creatures also live here: mule deer, horned toads, coyotes, rattlesnakes, and jackrabbits. Early in the day is best for the mammals; the birds move later when the warm thermals begin to rise along the canyon walls.

National Wildlife Refuges

CAMAS. Northwest of Idaho Falls, Camas (named for the lovely lily of the area) encompasses habitats from marshes and lakes to desert to irrigated meadows. In early April huge numbers of waterfowl congregate over what seems every inch of water. Large birds are easiest to find and photograph, and sandhill cranes and trumpeter swans both nest here. Other long-legged birds also stop. Coyotes are common in winter and mule deer are usually in evidence early and late in the day. Occasionally antelope are seen and even more occasionally, moose. It is possible that there will be a photographable bird being cared for in the refuge's raptor rehabilitation center.

GRAY'S LAKE. The now-famous, apparently successful plan to have un-threatened sandhill cranes adopt and raise rare whooping cranes was implemented here in eastern Idaho, approximately thirty-five miles north of Soda Springs. But the large rust-white chicks are well protected from intrusion and are difficult to see, let alone photograph. The best opportunities are from a platform near headquarters or from the dirt roads. (Whooping cranes are more easily photographed at Bosque del Alache Refuge in central New Mexico during winter.) Other creatures at Gray's Lake include moose and mule deer that drop young on Bear Island in the refuge, and foxes and coyotes that move throughout.

KOOTENAI. Just sixteen miles south of the Canadian border, this very small refuge nonetheless is home to a variety of wildlife. Fall is the best season for bird life. There may be thirty-five thousand ducks and geese in early November. Winter sees a number of bald and golden eagles. Ospreys stop in spring and fall. Watch for owls of several species. The area has recently been declared critical grizzly habitat, but the chances of seeing one are slim. There are also both mule and white-tailed deer. Moose and elk are seen less frequently than the deer. Black bear sightings are not out of the question. Coyotes, as everywhere, are ever alert for weak or inattentive waterfowl.

State Parks

BRUNEAU DUNES. The ceaseless winds of southwest Idaho cause the two huge dunes, approximately fifteen miles south of Mountain Home, to form and re-form over about six hundred acres of the dry basin. Low sidelight

defines the photographable textures of the sand. The fact that a lake and marsh exist within a desert area makes this an ideal spot for creatures of some variety. As in all desert areas, much of the wildlife is nocturnal, but during the day (especially the cooler times at each end) watch for coyotes, jackrabbits, raptors, and leggy burrowing owls that stand their ground beside nests tunneled in the loose soil. Use a medium telephoto lens to photograph these.

FARRAGUT. Lake Pend Oreille is a developed section in far northern Idaho known for its scenic beauty. The enthusiastic photographer should rise early to find solitude and search for white-tailed deer, black bear, coyotes, occasional elk, and seasonal waterfowl. Columbian ground squirrels are everywhere and easily photographed from a sitting position.

MASSACRE ROCKS. Travelers on the old Oregon Trail were forced at this place to proceed through a narrow defile. In 1862 ten were massacred by Indians doing just this. Today things are calm, and tundra swans, great blue herons, and bald eagles populate the area. The desert environment flora is the same as it was in 1862 (cactus, sage, and Utah juniper plus a few marsh plants), providing habitat for small creatures such as cottontails, muskrats, beavers, and coyotes.

PONDEROSA. On the western edge of the Gem State, north of McCall, Ponderosa lies on a peninsula in Payette Lake. Sagebrush flats, marshes, and lake shorelines make for varied scenery. Deer, waterfowl, and small mammals find sanctuary at the north end of the lake.

PRIEST LAKE. Within the granite peaks of the Selkirk Range, high in the Idaho Panhandle is Priest Lake. There are three park areas along the shore. This is one of those places where both mule deer and whitetails coexist. There are also populations of black bear, moose, and elk. Mountain goats are rarely seen.

THREE ISLAND CROSSING. Like Massacre Rocks, Three Island Crossing is on the Oregon Trail. The deeply rutted route (still visible today) led intrepid pioneers across the Snake River at this scenic crossing. Other than the shallow stretch of river, there are two items of photographic interest: the bison herd in one enclosure and the longhorn cattle (although not strictly wild) in another. Animals in a pen can pose problems for the photographer who must struggle to avoid signs of captivity in the background. On the other hand, the creatures are easily located and often accustomed to lenses aimed in their direction.

FLOAT TRIPS

Hells Canyon, also known as The Grand Canyon of the Snake River, forms the boundary between Oregon and Idaho. It is discussed in the Oregon section. Besides hiking the river-level tracks, it is possible and enjoyable to travel the route by white-water float trips. For information write: Idaho Outfitters and Guides Association, Box 95, Boise, ID 83701 and request their catalog of coming trips.

Another worthwhile inflatable raft trip is conducted on the Salmon River (also known as the River of No Return) and its tributaries. Huge "hay-

stacks" of rock part the surging waters and wild patches of foaming, roaring river alternate with benign interludes as placid as a farm pond. Steep rock walls rise straight from the riverbed in places and are easily negotiated by bands of bighorn sheep that come to drink. Large stands of orange-trunked ponderosa pines can be seen from the boat, and black bears forage in comparatively high densities. For information write; American River Touring Assn. (ARTA), 445 High Street, Oakland, CA 94601.

OTHER AREAS

For river runners whose appetite for the magnificent surrounding area is whetted, it is possible to step ashore for a more intimate encounter with the land from horseback or by foot. Shepp Ranch on the banks of the Salmon River is an excellent base for exploration. Trails lead to elk, black bear, deer, and even cougars that populate the area in numbers as large as the range will permit. For information write: Shepp Ranch, Box 5447, Boise, ID 83705.

WESTERN MONTANA

Not greatly changed since settlement, the Montana Territory, and particularly the western third, is a mixture of mountains, glaciated valleys, alpine meadows, lakes, streams, and rivers of unmatched magnificence. Billed as "the last of the big time splendors," Montana does not disappoint. The 147,000 square miles between Yellowstone National Park and Glacier National Park's northern boundary are happy hunting grounds for the wandering photographer.

NATIONAL PARKS

GLACIER. Over a million priceless acres of rugged, mountainous landscape make up Glacier. It is located in the western third of the state on the Canadian border. Although snowfields persist throughout the short summer months, the name refers not to them, but to the fact that glaciers originally shaped the terrain. Successive flows scooped typical U-shaped valleys and left depressions where blue lakes now lie. Dense coniferous forests struggled for footing in the thin soil, and waterfalls plunge from great heights. The grandest of the North American animals thrive in Glacier Park, and it is the last really firm stronghold of the grizzly bear outside of Alaska. The sole thoroughfare is Going-to-the-Sun Highway, a fifty-mile scenic road that crosses the crest of the Rocky Mountains at Logan Pass. The road is closed by snow in fall and not opened again until the rest of the country is thoroughly warmed by spring's sunshine.

Although wildlife can be seen from the road, the best photography is from the trails. Mule deer, elk, moose, and (less often) black and grizzly bears are seen. To see mountain goats at close range, hike from Lake McDonald to Sperry Chalet. Their white coats look best in fall; handfuls are loose and trailing in the wind in summer. Kids, adept at climbing impossible slopes almost from birth, are appealing at any time and not difficult to photograph, often peeking from behind the nanny's flanks.

A brown trout rises to gulp an insect on beaver pond in central Idaho. The valley of Silver Creek and the Saw-tooth Recreation Area are good places to combine summer trout fishing with nature photography.

The Birds of Prey Natural Area in southwestern Idaho may be the best place on the continent to count raptors on a spring or early summer day. This prairie falcon caught a ground squirrel, its principal prey, and is eating it.

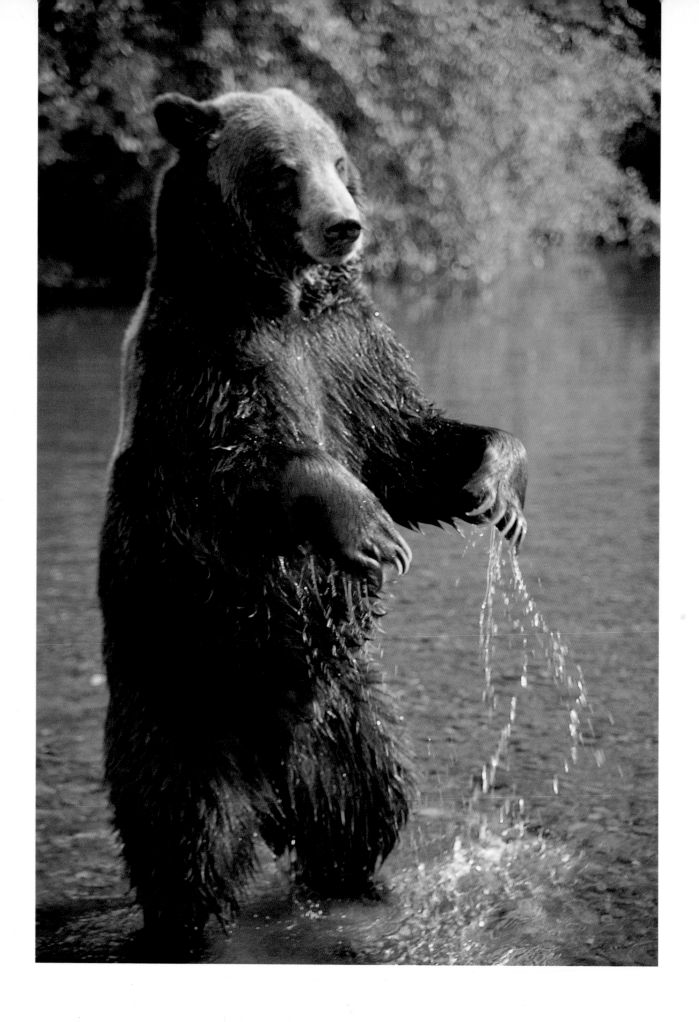

Windswept Logan Pass in Glacier National Park is not only an extremely scenic site, but wildlife concentrate there in summer. Goats are especially visible, and the occasional grizzly passes by. Bighorn sheep can be spotted on surrounding mountainsides. In July the pass area is ablaze with wildflowers, especially beargrass.

Autumn in the West is time to revel in the fall colors. Photograph the scarlet and golden mountain slopes. But watch also for the fallen leaves of quaking aspen and the glorious color of wild rose.

The grizzly bear is no longer easy to find and photograph south of Canada and Alaska (opposite). A few hundred, however, cling to existence in Glacier and Yellowstone national parks. Shooting bears should not be done carelessly.

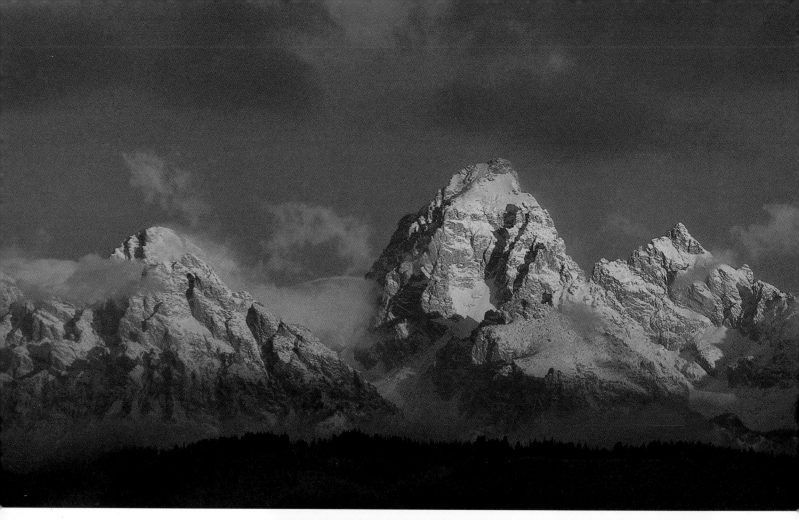

The Teton Range of Grand Teton National Park is among the most photographed landmarks in America. For a fresh viewpoint, rise before dawn and shoot the mountains when the first rays of the sun touch only the peaks. It is a rare and lovely sight.

An alert photographer can find subjects more easily during a Wyoming springtime. The coyote pups were photographed starting one of their first forays from the home den.

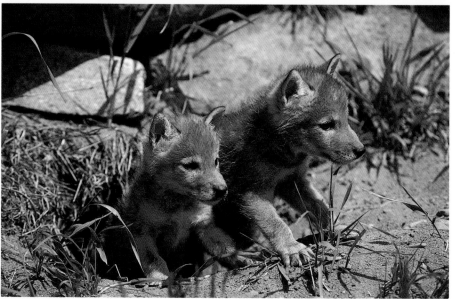

Large sections of the park are closed to hikers each season to avoid possibly dangerous encounters with the fairly numerous grizzly bears. (Always view any bear anywhere with great caution and never approach them closely.)

Bighorn sheep may be the most photographable large mammal in Glacier Park. They are usually near Many Glacier Hotel on the east side of the park. After a climb (less difficult than it at first seems), the animals can be photographed with great peaks as a fitting background. The rams often stand as if to pose. Many Glacier Hotel is a wonderful base of operations for the nature photographer. Situated beside Swiftcurrent Lake, scenic alpine photographs can be made even from inside the building. Boat trips run from the hotel's shoreline and continue on majestic Josephine Lake where mountain ranges are mirrored on the early morning-still waters. Trails into the magnificent backcountry begin nearby. In the late fall the wild sheep are often seen on the hotel grounds themselves.

Eagles congregate at the mouth of Lake McDonald from mid-October through November to feast on the salmon that have spawned and died there. A high count was 571 birds on November 28, 1984. Viewing and photography are restricted to the bridge there, and the only way to get good photographs is to have a very long (at least 400mm), fast (since the weather is often overcast) lens mounted on a tripod. The birds sit high and quite far from the bridge on tall trees edging the river. They occasionally swoop into the water and then return to land on overhanging branches.

NATIONAL BISON RANGE. Between Flathead Lake and Missoula, this reserve of great rolling grasslands looks much as it did before the arrival of the white man. Hundreds of bison roam at will attending to their seasonal chores of raising young calves, grazing, and rolling in the dust, huge hooves kicking the air in a small cyclone of earth. The bison share the area with white-tailed and mule deer, antelope, bighorn sheep, and elk. The bison begin their mating season in late summer when the bulls push and fight across the grassland. Later the amorous bull elk, carrying shining new antlers, bugle in the early morning. Deer can be seen in the heavy brush near the ponds and along the Jocko River that curves through the refuge. A nineteen-mile-long gravel road unwinds in slow horseshoe curves up two thousand feet from the floor, passing at good camera range the many animals that live a comparatively comfortable, safe existence here. A short hiking trail in the pond area is often rewarding for the photographer. Look for turtles, skunks, deer, and the large number of birds that are common on the refuge. Otherwise foot travel is not permitted.

RED ROCKS LAKES. In the Centennial Valley at the foot of the Continental Divide on the Montana/Idaho border are sixty-two square miles of lakes, marshes, and meadows that comprise the refuge. For a long time it appeared this would be the gravesite of the last of our trumpeter swans, but fifty years ago the necessary steps were taken to preserve them, and their numbers have risen to a level where their survival is no longer in doubt. Some have even been moved to reestablish populations elsewhere. They can be seen at Red Rocks, but only from a great distance. In winter the birds are fed at MacDonald and Culver ponds. The National Elk Refuge in Jackson, Wyoming, or Yellowstone Park provide better opportunities for photographing them. Easier to film at Red Rocks are the sandhill cranes that nest there, white pelicans, tundra swans, and various species of ducks.

In August and September fifty thousand waterfowl congregate. Moose are year-round residents; mule deer, elk, and antelope can be seen except in winter. The usual Rocky Mountain West aggregation of small mammals—porcupine, badger, red fox, and coyote—are here, too. The refuge road is usually closed in winter.

OTHER AREAS

THE BEARTOOTH HIGHWAY. For the confident driver in a reliable vehicle, the Beartooth Highway is a splendid opportunity for magnificent scenic photography. The sixty-five-mile-long roadway from Cooke City to Red Lodge is narrow and winding, and open only from when the last of the snows can be plowed off (late May) until new snows again close it (often before Halloween). But the scenes of jagged peaks, deep canyons, and the twinkling strand of Rock Creek far below are worth a few heart-stopping moments on the road. Mountain goats can often be photographed along the highway. There are turnouts where one may take photographs (and regain one's composure).

WILDERNESS AREAS

Not surprisingly, Alaska has the most wilderness lands of any state. But Montana is second with more than four million acres on and within its borders. There are a dozen such areas between Yellowstone Park and Glacier National Park, any one of which is a worthwhile stop. The three selected here are of special interest.

ABSAROKA-BEARTOOTH WILDERNESS. On just a two-mile hike, you can view many lakes in the low pockets of this high, wild area. Twenty-five peaks rise about twelve thousand feet.

BOB MARSHALL WILDERNESS. Most of western Montana is steep and rugged, but the Bob Marshall is different. Here there are wide meadows, placid lakes, and a generally benign habitat known for its abundant wildlife. There is the Chinese Wall, a fifteen-mile-long, one thousand-foot-high rock rampart where mountain goats walk. Other creatures live below. The largest of the western Montana cities: Kalispell, Missoula, Helena, and Great Falls encircle the Bob Marshall, and it is within two hours drive of any of them.

MISSION MOUNTAIN WILDERNESS. West of the Bob Marshall Wilderness, the Seeley-Swan Lakes Valley is lush and green in summer and surprisingly mild in winter. The Mission Mountain Wilderness is high above the valley in a wild landscape topped by glaciers. Lakes formed by their summer meltwater are turquoise blue. Deer, mountain goats, and wandering grizzlies live in the area, and wildflowers bloom in colorful profusion from spring to late summer.

NATIONAL WILDLIFE REFUGES

METCALF. Formerly called Ravalli, Metcalf (twenty-five miles south of Missoula on the Bitterroot River) has a nice variety of wildlife. Red foxes

occasionally den near the roadside, and coyotes arrive in winter. White-tailed deer can be seen at any time. Birds, of course, are most numerous: twenty thousand ducks may arrive in spring and fall migrations and hundreds of tundra swans stop off. Ospreys arrive in April and forcibly take over the nests of Canada geese that have nearly completed their family chores for the season, anyway. Regular visitors enjoy seeing the painted turtles as much as anything else. Other small mammals include raccoon, skunk, mink, muskrat, and occasionally bear and moose.

WESTERN WYOMING

The largest, most exciting and potentially the most dangerous wild creatures still roaming the lower forty-eight live in the northwestern section of the Cowboy State. Both black and grizzly bears, horned animals—bighorn sheep, antelope, and bison—and antlered-animals—elk, moose, and mule deer—can be found in this remote corner of the state. All live in magnificent, scenic places and are easy to find and photograph at the right time and in the proper place. Smaller animals include ground squirrels, marmots, martens, coyotes, and (in summer) a wide diversity of birds. Wildflowers follow the retreating snows up the mountainsides in a predictable sequence beginning in June and lingering until the last blooms are powdered with snow as early as October.

NATIONAL PARKS

GRAND TETON. The best opportunities for grand scenic photography exist in Grand Teton, which is south of Yellowstone National Park. The three sharp peaks of the Cathedral Group in the Teton Range are the centerpiece, and they are flanked by others only marginally less outstanding. The mountain mass rises without the preliminaries of foothills directly from the sagebrush flats of Jackson Hole. Early morning or evening colors change from pink to lavender to a gray purple. The Snake River flows at their feet edged by quaking aspen and evergreens. Just after sunup is the best time to photograph the larger wildlife species: elk, moose, mule deer, and antelope. By 9:00 A.M. or 10:00 A.M. many have retired to hidden glens. Look for elk grazing near Timbered Island, a densely wooded area not far from park headquarters. Mule deer does and fawns graze beside trails in alpine meadows; the bucks remain high and hidden until the autumn rutting season. One would expect moose near lakes and ponds, but they browse tender twig tips near the higher trails, too. Antelope are always on the level, open sagebrush flats and are visible throughout the day. The small band of bison grows each year and wanders unpredictably. Pairs of trumpeter swans, rare elsewhere but common here, cruise the Sawmill Ponds near park headquarters and other ponds as well. Elk and deer are much more in evidence in fall than any other season. The best times to visit are summer and autumn. Most roads are closed in winter,

YELLOWSTONE. Our oldest and largest national park, Yellowstone occupies the entire northwest corner of the state and even spills over into Idaho and Montana. Best known as the home of Old Faithful, a geyser that maintains a fairly regular hourly schedule of performances, the park also

has about two hundred additional thermal features. Some steam, others spout superheated water, and a few only gurgle. Mud pots roll and boil, the bursting bubbles etching perfect circles in the thick soup. Though scenically less spectacular than Grand Teton, Yellowstone is an extraordinary wildlife spectacle.

Summer, when the vast majority of visitors arrive, is the poorest season for wildlife viewing, but even then the early risers can find creatures still up and about after a night's grazing. Elk are common around Mammoth Campground at the north end of the park, and their increasing numbers may account for the fact that mule deer are now seen here less frequently than in the past. Firehole Flats are often covered with bison cows and their rusty calves. Some bison bulls may linger in Hayden Valley, which is also a good place to look for moose. Canada geese, trumpeter swans, and ducks can be viewed on the waterways from the road. You will probably not see a black bear at any season and although a very few grizzlies have been glimpsed recently, their numbers have been greatly reduced by the park policy (in force since the early 1970s), which abruptly closed garbage-feeding areas used by the bruins. Bears found near heavily used areas are relocated, and if they return to the area more than once they are killed. Many bears have perished (some from the tranquilizers used), and their numbers have never recovered. Today they are more endangered than ever.

Fall is by far the best season for wildlife in action. Bull elk bugle in the frosty morning air and protect their harems from the attentions of other possible suitors. Bulls of equal size often engage in furious contests, crashing antlers together with terrible force. Moose pursue one female at a time and are common at the Pelican Creek area. The Lamar Valley on the east side of the park is generally good for all of the park's creatures. In late fall the cliff faces and high grassy plateaus near the Gardiner River are the scene of bighorn sheep mating rituals. The ring of horn against horn sounds in the canyons, sometimes echoed by the crash of elk antlers from a nearby ridge. A siege of pinkeye killed a great number of bighorns in 1982, but a sufficient number survived to replenish their numbers in more recent years.

Only the road that arcs across the northern border of Yellowstone is open in winter (October to May). Entrance otherwise is restricted to private snow machines and public snow coaches that transport visitors from either the south entrance at Flagg Ranch or the west entrance (a better route for photographers) at West Yellowstone, Montana. The coaches stop frequently for picture taking. After fall, winter is the next best season for visiting the park, because the animals are far more tolerant of human presence. Deer, elk, and bison are almost impossible to miss. Moose have wisely moved out of the area. For information on snow coach trips and accommodations in the park write: Yellowstone Park Division, TW Services, Inc., Yellowstone National Park, WY 82190.

NATIONAL WILDLIFE REFUGES

NATIONAL ELK REFUGE. When the town of Jackson grew in the 1920s, it blocked the traditional migration route of thousands of elk. A refuge was established north of the town to sustain the creatures over the bitter winters and to prevent the animals from raiding ranchers' haystacks. Each November over five thousand and sometimes up to eight thousand animals gather here. When deep snows or icy crusts cover the natural forage, the elk are fed by refuge personnel. In April they again leave for the high country.

Horse-drawn sleds carry visitors to within close camera range of the herd from Christmas until the snows melt. Happily, elk bulls retain their antlers until spring. They are easy to photograph with the majesty of the Teton Mountains as a background. A predictable number of elk succumb each season to natural causes, and ravens, eagles, magpies, and coyotes see that no elk carcasses go to waste. Mule deer winter on the buttes beside the refuge road and Barrow's goldeneyes, mallards, and several pairs of trumpeter swans keep warm on the thermally heated ponds. There is a photo blind beside the steaming waters that may be used with special permission of the refuge manager. No foot traffic is permitted.

OTHER AREAS

WYOMING WATERFOWL TRUST. The Wyoming Waterfowl Trust opened in the spring of 1986, seven miles north of Cody on Belfry Road. A collection of waterfowl from throughout the world is on display including cranes, geese, swans (all eight species of the world), and ducks. These birds, some rare and endangered, can be seen and photographed from a self-guided trail. It is planned to eventually have one thousand birds, half native to North America, and half from elsewhere on earth.

WESTERN ALBERTA

Alberta's Canadian Rockies have some of the most awe-inspiring mountain scenes in the world. Tall rocky peaks, range upon range of towering mountains, open wooded valleys, clear waterways, canyons, glaciers, and icefields are all here in their natural magnificence. Several glaciation periods formed much of what we see today. Elevation determines the vegetation and therefore the wildlife that can exist in any single place. Generally mountain goats and bighorn sheep favor high alpine areas, elk and mule deer the forest meadows, and moose the marshy valley bottoms.

Note: We use metric measurements here to conform to Canada's system.

NATIONAL PARKS

BANFF. For the best wildlife photography look around the Banff townsite in the early morning for both elk and mule deer. Listen for the bugle of the elk in fall and look along the Bow River where a group may cross. Watch for small evergreens that have been stripped of both limbs and bark by bull elk polishing their antlers. The animals will not be far away. Open meadows behind roadside trees are likely areas to spot elk. Deer are more approachable in the fall too, and fine bucks can be seen from the trails and also from roadsides. There are mineral licks near the main park road (look for the signs), and mountain goats frequently come for this important addition to their diet. Look in high open alpine meadows for bears. Just west of the Banff traffic circle on the main highway is a buffalo paddock where the creatures wander over one hundred fenced acres.

Almost any trail takes a hiker/photographer to scenic areas. The best

known in Banff is Lake Louise. Perhaps the most photographed lake in this part of the world, Lake Louise makes a marvelous subject for the photographer visiting Canada. From the parking area at the lake you can stroll along the south shore. Sadly, this section is increasingly covered with asphalt, docks, and other intrusive elements. Along the shore trail find the Fairview Lookout for another view of the deep blue lake.

During the summer months the park can also be seen from horseback, raft, or one of two gondola lifts for panoramic vistas.

Banff, northwest of Calgary, is connected to Jasper National Park by the wonderfully scenic Ice Fields Parkway (see pp. 95–96).

JASPER. Located north of Banff, Jasper National Park is very similar to Banff National Park. Both are largely mountainous; the peaks were once layers of rock beneath an ancient sea bed. Relentless glaciers covered and carved the area. For a good part of the year mule deer, elk, and moose can be found on the lower slopes and in the meadows.

A tour of the roads within the townsite of Jasper and on its edges in the early daylight hours can be rewarded by the sight of a band of elk. In the fall the herd bull may prod his harem across the Athabasca River to one of the small forested islands in midstream. They may use the same route on successive mornings.

Large-antlered mule deer bucks also frequent the town and can sometimes be found in the wooded areas along the railroad tracks. These too are most easily photographed in the fall when their natural shyness is overcome by the excitement of the rutting season.

Bighorn sheep graze high and often beside the road. A photographer who slowly ascends the steep hillsides can approach the herd quite closely and use the impressive mountaintops all around as a background.

Black bears forage along the roadsides and in open woodlands and especially near the campgrounds if garbage has been left by careless campers. Grizzlies remain at higher elevations. Great care must be taken when photographing either of these carnivores.

Driving the roads is the quickest way to find wildlife to photograph, but do not overlook the 960 kilometers of trails in Jasper since all wildlife photographed here will be in its native and natural environment. During the tourist season it is also possible to take horseback rides and raft trips through the park. Bus tours run to the most scenic areas.

WATERTON LAKES. Adjoining Glacier Park in Montana, Waterton Lakes is geologically the same, but in philosophy quite different. Rather than preserving the natural world as much as possible, the Canadian park is more of a summer resort. The motels have swimming pools, there is an eighteen-hole golf course, and privately owned motorboats race across the lake. However, the nature and wildlife lover can still find ample enjoyment here. Seventeen kilometers northwest of the townsite is Red Rock Canyon, cut by a scenic roadway where bighorn sheep and elk can be seen. Mule deer frequent the trails to Blakiston Falls. Shy coyotes can be anywhere. During the summer months drive through the buffalo paddock where there are twenty plains bison. Scenic boat cruises are available here during summer months. The 183 kilometers of hiking trails are interesting and views from the summits down to Waterton Lake and the mountains that jut from the shoreline are worth the effort expended in the climb. When they cross park boundaries, elk are prey for hunters and are extremely wary of any human presence, even in a vehicle. They are impossible to photograph because they

gallop off when humans approach them. The sheep are much more confiding, but in recent years their numbers have been decimated by disease.

WOOD BUFFALO. Although not in the western part of the province, we mention this park since it is Canada's largest (even extending over into the Northwest Territories) and in several ways unique. Established in 1922 to protect the rare woodland bison, today it is also home to the plains bison and, sadly, to a large hybrid herd. The topography is varied, from salt plains to heavily forested erosion plateaus to immense marshes in the southeast. Over two hundred species of birds nest in the park (including whooping cranes). There are also moose, elk, and caribou. The park offers conducted hikes, evening slide programs, and guided canoe trips in summer.

However, Wood Buffalo National Park is located in a remote corner of Alberta, and it is extremely difficult to reach. The infamous swarms of mosquitoes, the most vicious animals in the park, can also be a deterrence. For information write: Park Superintendent, Box 750, Fort Smith, NWT XOE OPO, Canada.

PROVINCIAL WILDERNESS AREAS

There are four wilderness areas: Ghost River, Siffleur, White Goat, and Willmore, all tucked beside either Banff or Jasper parks. Each is an area of virgin land set aside to preserve its natural state forever. All access is by foot only, all wildlife is strictly protected and not even a piece of gravel may be removed. For the photographer with an urge to find solitude and nature untrampled, these are the places to spend some time.

OTHER AREAS

POLAR PARK. Just fourteen miles east of Edmonton on Highway 14, Polar Park is a home the resident creatures can barely tell from their ancestral habitats. Some of these northern latitude animals wander at will, others are in naturalized enclosures. They include snow leopards, Himalayan tahrs, Siberian tigers, Bactrian camels, polar bears, musk oxen, and caribou. The new Cougar's Lair Chalet houses the few that cannot remain outside the entire year. This is a pleasant, attractive place where it is easy to photograph the animals throughout the year. For more information write: 51419 Range Rd. 223, Sherwood Park, Alberta T8C 1H4, Canada or telephone 403/922-3401.

ICE FIELDS PARKWAY. This unique highway runs for 230 kilometers from near Lake Louise in Banff Park to the town of Jasper in Jasper National Park. It ranks among the great highroads of the world and commands some of the most majestic scenery in the Canadian Rocky Mountains. A series of mountain ranges run in a northwest to southeast direction, and the highway follows the sweeping valleys between. It is possible to spend many days here, camping and making daily hiking trips into the quiet valleys and alpine meadows. But even on a less leisurely trip there are several stops for the photographer. Along the southern third of the parkway are a series of lakes; one of the most scenic of these is Peyto Lake. At the summit of Bow Pass, follow the short trail to a viewpoint overlooking the lake and Mistaya Valley stretching 32 kilometers to the North Saskatchewan River. It is

especially lovely in winter when it lies like a pale turquoise gem in white velvet snow. The evergreens surrounding the lookout make a fitting frame for the scenic photograph. Farther to the north crouches the Columbia Ice-field, once part of the vast ice sheet that covered most of Canada for more than one million years. It is the largest accumulation of ice in the Rocky Mountains and spawns rivers that eventually empty into three oceans and Hudson's Bay. Glaciers spread where the icefield has overflowed its valley. Three can be seen from the parkway: the Saskatchewan, the Dome, and the Athabasca. For an intimate look at a glacier, park in one of the designated areas and walk to the very face of the ice. You will hear the trickle of water from beneath the ice mass. The ice constantly cracks and grinds and groans like a living being. The surface of a glacier usually has a film of dirt blown by summer winds, but is white below that. Deep in the fissures where the ice has been compacted it is sapphire blue.

Moose are occasionally seen beside the roadway as are bighorn sheep, elk, and bear, but this is the place for scenic photography, not wildlife.

BRITISH COLUMBIA

The awesome mountain scenery of this Canadian province is justly famous. The typical vistas of soaring, snowcapped peaks, verdant valleys, and clear waters, common in the Canadian Rocky Mountains, would be the pride of any country. Sadly, unconscionable logging practices have devastated much of "Beautiful British Columbia." But the scenery that remains plus the presence of the most impressive large mammals in North America attract serious photographers from everywhere.

There are five national parks in British Columbia and more than three hundred provincial parks. Access is by good road, and often by air or water. We discuss here only those of particular interest to the photographer although there are many additional public lands left for private discovery.

Note: We use metric measurements here to conform to Canada's system.

NATIONAL PARKS

GLACIER. The Glacier Park in Montana is named for the forces that formed the park and have now passed. Glacier in British Columbia has a different meaning altogether. Here the name refers to the massive ice flows that currently cover 12 percent of the surface of the park with four hundred glaciers. The park is located in the Columbia Mountains, one of the most rugged areas of western Canada, where there are deep, narrow valleys and massive bedrock formations. Only a narrow strip on the eastern border differs with its broad valleys and layered sedimentary rocks similar to those of Banff and Jasper parks in Alberta. Because of the great amount of precipitation Glacier is one of the world's most active avalanche zones.

Although the Trans-Canada Highway, which bisects the park, is open year-round, it is better to come only in summer and hike the trails with photo equipment in a day pack. Generally the lower elevations are snow free from May to early November. The higher elevations are hikable only from late July to early September. The best wildflower show is the first two weeks in August.

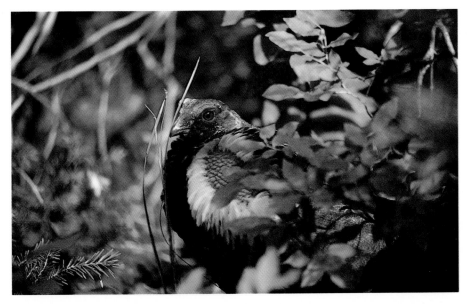

Keep a sharp lookout for blue grouse along higher hiking trails in the Alberta Rockies. In late spring and early summer, the color and courtship display of male grouse is rewarding to photograph.

The first snow of fall covers Mount Athabasca near the Columbia Icefields south of Jasper, Alberta. During midsummer the same slopes are blanketed with alpine wildflowers. Bighorn sheep are often seen here, even near the highway.

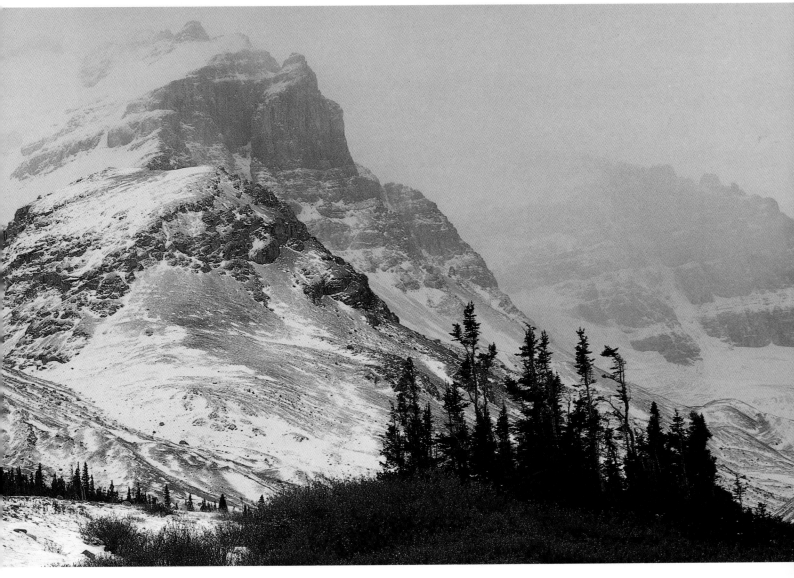

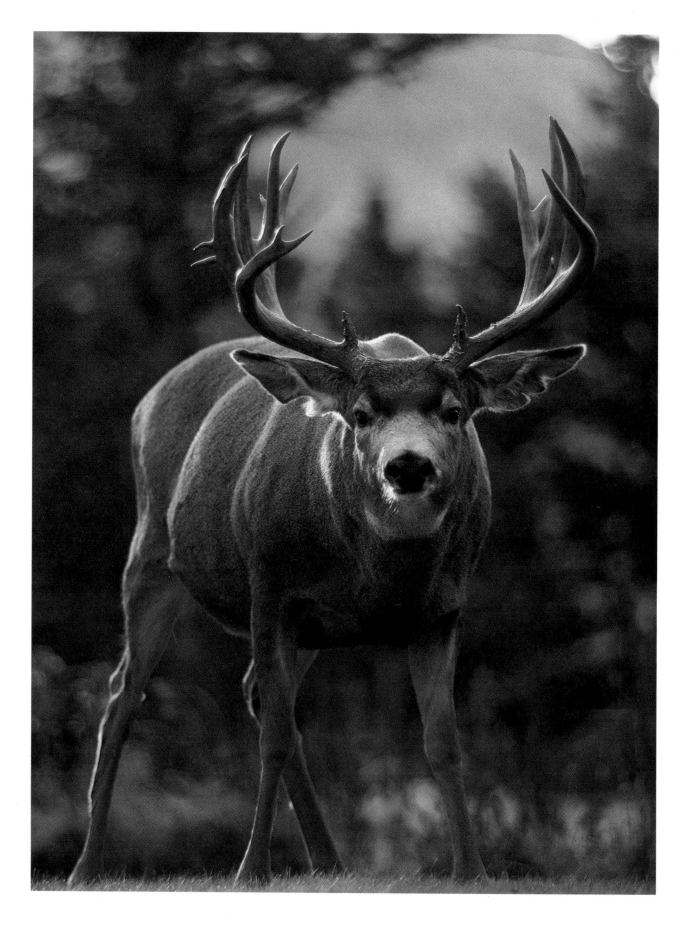

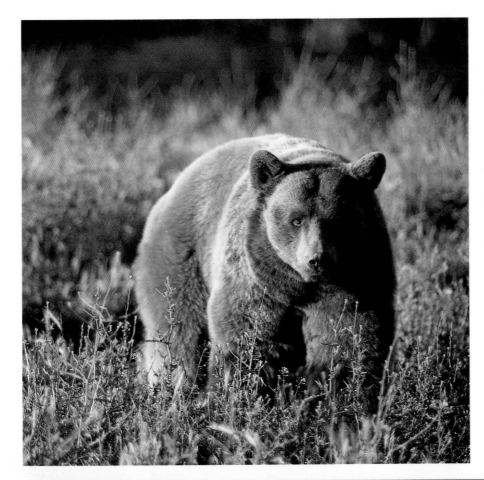

Early and late in the day mule deer can be seen along roads and hiking trails in Alberta parks. This sleek antlered buck (opposite) was photographed in September.

Black bears, this one a cinnamon phase, are fairly numerous everywhere in British Columbia, but are most often observed in several national or provincial parks such as: Yoho, Kootenai, Mount Robson, Mount Revelstoke, and Glacier.

Stone sheep, a gray subspecies of the Dall sheep, can be photographed only in British Columbia. To find them it is necessary to backpack or horsepack into the Cassiar Mountains. On rare occasions the sheep can be seen from the Cassiar Highway.

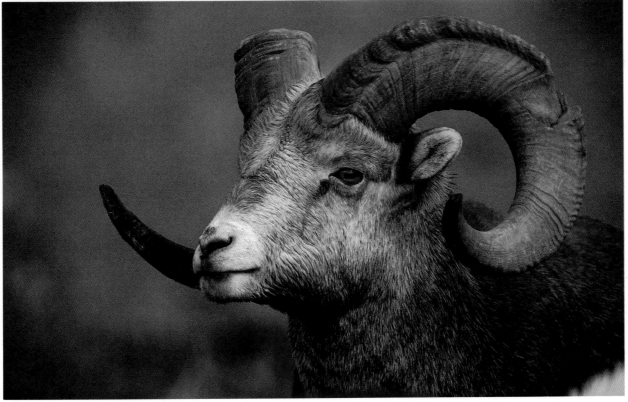

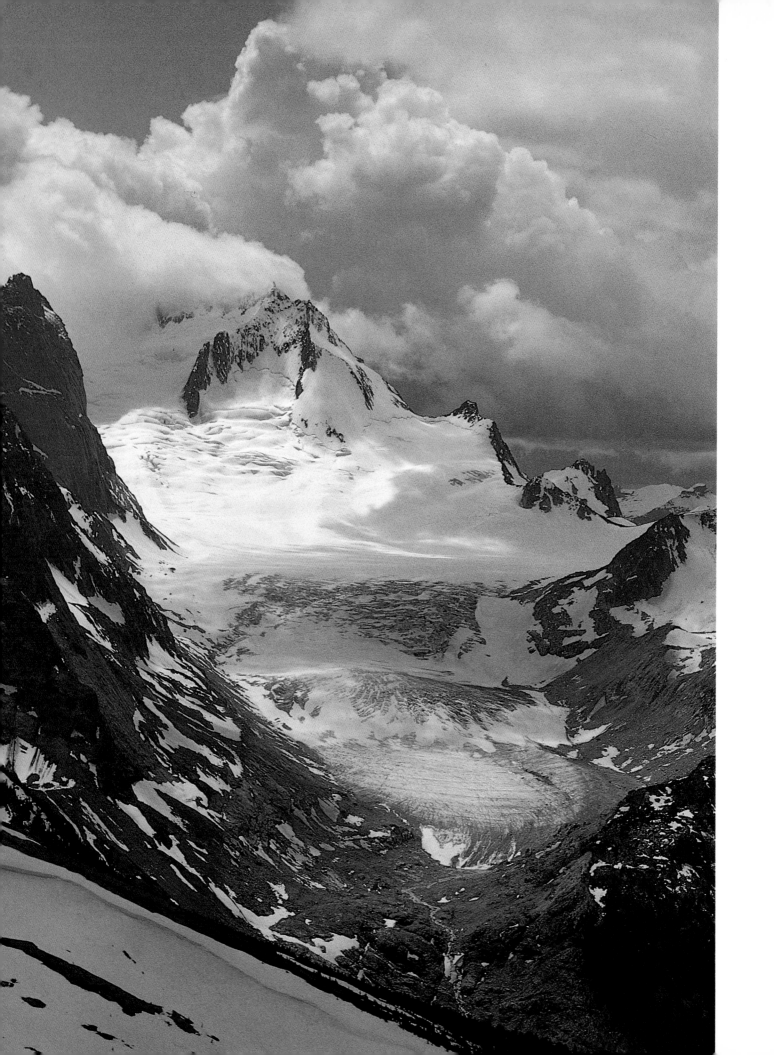

Wonderful mountain scenes are abundant; the dark forests of western red cedar and western hemlock cover the valley bottoms, spruce and fir and hemlock occur higher up. But more than half the park is above tree line. Such inhospitable habitat limits the wildlife. Moose and mule deer are uncommon, and only mountain goats are really well adapted to withstand the winter environment. Occasionally they can be seen on ridges and cliffs facing the highway. The large alpine meadows and open avalanche-battered slopes are perfect for both black (at lower elevations) and grizzly (at higher reaches) bears. Be alert for their presence and photograph them only from a great distance.

KOOTENAY. Kootenay, which is on the west slope of the continental divide, is similar to Banff National Park in Alberta on the east side. The more southerly portions are noticeably warmer and drier than the northern areas and any part is better seen and photographed from the many trails that lace the terrain. Firs, pines, and spruce grow below timberline, and above the windswept meadows are covered with wildflowers such as mariposa lily, avalanche lily, and heather in summer. The larger species of wildlife include elk, mule deer, and mountain goat. The goats are most easily seen on Mount Wardle from the highway. Elk and deer range near timberline in the warmer months. Bighorn sheep graze on high meadows too, but also appear near Radium Hot Springs where they come for the natural mineral licks. They spend the winter on grassy slopes at lower elevations. Black bears range throughout the park and grizzlies can sometimes be seen in the spring on the steep avalanche slopes above the Vermilion River.

MOUNT REVELSTOKE. Mount Revelstoke offers the only opportunity in Canada to drive to the summit of a mountain. The road switchbacks through four life zones from bottom to top. Each life zone is an area with its own climatic and physical peculiarities. The moisture (or lack of it) and the soil properties determine which plants and animals will live here and when flowers will bloom. There are sixty-five kilometers of established trails, and hiking these is the best way to gain intimate knowledge of the park. Driving the road, however, is a good way to become acquainted with the park.

The lowest level is a rain forest with cedar and hemlock trees towering over a dense understory of devil's club, alder, and bracken. Next is the subalpine forest. The third natural area is the meadows, where due to increasingly severe climate, the trees disappear. These open slopes in summer are covered with a wonderful variety of wildflowers, and it is this profusion of color that has made Mount Revelstoke famous. On a recent summer trip, we counted a dozen different blooms. Snow still covered much of the terrain. It was tinted pink in patches and known as "watermelon snow." Most photographable is the glacier lily, which is strong and vigorous here with a marvelous melted butter hue. At lower elevations, the Columbia lily is the most noteworthy flower. Columbian ground squirrels and hoary marmots warm themselves on sunny rocks. At the top only rocks and ice are truly comfortable, and a mixture of saxifrage and grasses struggle for a hold. From the summit there are views of the Columbia and Illecillewaet river valleys. The Monashee Mountains can be seen from vantage points along the scenic drive.

There is a pleasant nature walk at the Giant Cedars section of the park. The curving boardwalk through a cedar forest is a green fairyland on bright mornings. The low rays illuminate the large leaves of devil's club and outline the delicate foliage of red cedar. Mosses and ferns are lush in low

British Columbia is a province of numerous mountain ranges, each more magnificent (and photogenic) than the next. We photographed this scene of lonely peaks and summer snowfields (opposite) while heli-hiking in the Bugaboo Mountains.

damp areas and cover the fallen logs on the forest floor. A tiny creek gurgles over stream bed rocks. The walk is short, but well worth a brief visit.

PACIFIC RIM. Pacific Rim, the first national marine park in Canada, lies on the southwest shore of Vancouver Island. It is divided into three sections: the Long Beach Unit, the Broken Group Islands, and the West Coast Trail.

Except for a commercial cargo vessel that docks at one of the islands (and this only in summer), access to the island group is over open and often dangerous water. The West Coast Trail is not yet incorporated in the park and walking the trail is a difficult, unrewarding experience. We, therefore, suggest that the visitor spend his time in the Long Beach Unit. The area is reached via British Columbia Highway 4, which traverses Vancouver Island and passes through miles of once forested land now ravaged and denuded by unregulated logging practices that should bring shame to any government. Pacific Rim was spared only because logging there was not considered profitable. The best way to see this section is by hiking the trails, choosing those that wind through different kinds of environments: bog, muskeg, and woodland.

The Shorepine Bog Trail is dominated by the shore pine tree, a stunted miniature of the lodgepole pine found inland. The acidic waters prevent normal growth and some of the trees, while three hundred years old, are only a few meters high. Layers and layers of sphagnum moss float on the water that covers the bog; their colors of green, brown, and red make an attractive foreground for photographs of the trees.

Half Moon Bay Trail leads through a forest of cedars and hemlocks twisted by years of exposure to wind and salt spray. Look too for nurse logs—toppled trees that become, as the moist wood begins to decay, a seedbed for a host of plants. Armed with a closeup lens look for fungi and hemlock sprouts, and for the millipedes, salamanders, banana slugs, and toads that prey on the insects in the rotting wood. The trail then leads through a stand of sword fern and finally descends to the sands of Half Moon Bay.

The most interesting plant on the Wickaninnish Trail is the sundew, a fascinating piece of flora that attracts insects to its sticky leaves and then digests the entangled victim. It is thought that plants that cannot derive sufficient nourishment from the soil develop this method of obtaining the necessary nutrients. Dropping to hands and knees with a closeup lens is the way to photograph the plant.

Mammals are not very abundant in dense forests, but black-tailed deer are sometimes seen along the shoreline and in logged over areas (one of the few positive things to come from clear cutting forests). Now and then someone will see a black bear, and cougars have been observed crossing roadways. Because the park is on the Pacific flyway, thousands of ducks and geese pause here during spring and fall, but are not easy to photograph as they are wary and keep a distance from humans. Most photography will be of the coastal scenes, the forests, and the tiny creatures in tide pools and on nurse logs.

YOHO. Yoho is the Cree Indian word expressing awe, and awesome is just the right adjective for this park, abounded by Banff and Kootenay parks on the east and south. There are rock walls, waterfalls, deep forests, snow-capped peaks, and delicate wildflowers. Although the park is open year-round, the best time to photograph it is in summer while exploring the trails.

Three life zones can be seen in Yoho: the montane, subalpine, and

alpine. The lower two are best for wildlife, which includes moose, mule deer, elk, and black bears. The bears are of special concern to park personnel (as everywhere) and care should be taken not to lure them with food (intentionally or not). The highest elevations are in the alpine zone. Mountain goats, grizzlies, marmots, and pikas travel this area.

PROVINCIAL PARKS

GARIBALDI. Like so much of British Columbia, Garibaldi has massive, awesome scenery. However, it is primarily used by backpackers, experienced mountain climbers, and fishermen. Winter comes early and snow often lingers until early August. Deer, mountain goats, grizzly bears, and black bears are present in the park, but very seldom seen. There are three areas that have some visitor-oriented development: Diamond Head, Black Tusk, and Cheakamus Lake. Two camping areas and an alpine shelter accommodate thirty people. Garibaldi is within easy driving distance of Vancouver.

KOKANEE GLACIER. Like Garibaldi, Kokanee is an extremely rugged, undeveloped park that attracts hardy climbers, hikers, and photographers. It is located in the extreme southeastern corner of British Columbia. The park is named for the glacier that clings to Kokanee Peak in the center of the park. There are many other glaciers too, as well as thirty lakes encircled by precipitous cliffs and rock slides. Amid the wild beauty the large mammals roam, but nowhere in abundance. There are mountain goats, deer, and both black and grizzly bears. Small critters are more numerous. Among the larger birds are the blue and Franklin's grouse. There are two cabins for public shelter.

MOUNT ASSINIBOINE. This provincial park lies in what many consider the most beautiful area of British Columbia. It is bounded by Banff (in Alberta) and Kootenay national parks. The scenery is as wildly magnificent as any in the Canadian Rocky Mountains. Toothed peaks loom over glittering lakes, glaciers, and alpine meadows. More than a score of mountains stand about twenty-seven hundred meters in elevation. Very little development has taken place leaving the parks delicate ecological balance unspoiled. Only Mount Assiniboine Lodge near Lake Magog accommodates guests. Nearly all access is by trail, and there is camping above the west side of Lake Magog. There are, in addition, four very popular alpine cabins. Entrance by helicopter is permitted occasionally. The scenery is the most photographable feature of the park, but the same big game animals that the Assiniboine Indians hunted in the past remain. Elk and mule deer forage in open areas, and moose browse in the bogs and marshes at lower elevations. Mountain goats, bighorn sheep, and even a bear can be seen high on rocky crags. Smaller mammals are infrequently glimpsed.

MOUNT ROBSON. No one is certain just which Robson the park was named for, but all agree on its impressive scenic beauty and the fact that Mount Robson is the highest peak in the Canadian Rockies. It towers 3,954 meters over the western entrance to the park. The park is bordered on the east by the continental divide and Jasper National Park (in Alberta). Scenes of snowcapped mountains, deep valleys, clear waters, and forests typical of the western slopes of the Rockies combine to make this a wonderful

destination for the photographer. Kinney Lake, on the trail to Mount Robson, provides a mirror for the mountains that surround it. Vegetation is characteristic of the Columbia and subalpine forests that are found in the nearby parks.

Moose may be seen in the marshes at the east end of Moose Lake, while mountain goats and grizzlies frequent the rock slides on the north side of the highway and Yellowhead Lake. Caribou range the high basins and tablelands. Mule deer and black bears are found throughout the park, while elk roam the eastern region. Grouse are easy to spot because they are large birds and often comfortable with human presence.

A lookout near the western entrance to the park gives visitors a view of Rearguard Falls. The Fraser River parallels and is crossed by the highway through much of the park. Overlander Falls and gorge are a short distance by trail from the highway just east of the park's western boundary.

OTHER AREAS

BUGABOO GLACIER PROVINCIAL PARK AND ALPINE RECREATION AREA. By far the easiest and most comfortable way to see and photograph this magnificent alpine area, a neighbor to Banff and Jasper national parks, is to helicopter to the most spectacular scenic areas. Within minutes of lift-off, the photographer can be treading virgin terrain that no road and few trails will ever conquer. Easy or more strenuous hiking tours are accompanied by knowledgeable guides who identify the massive snowcapped peaks and wildflowers that bloom so briefly in summer. The hiking tours allow plenty of time for photography. Glaciers grind inexorably downward, their melting undersides gathering into streams that merge to form jade green lakes at every depression. Flocks of horned larks twitter and peck at the seeds invisible in the shaley layer underfoot. Milky quartz chunks are scattered profusely and green and orange lichens grow anywhere. The few trees are wind stunted and bent like bonsai trees. Massive rock outcrops such as Marmolata Spire jut from brilliant snowfields. For information on these excursions write: Tauck Tours, P.O. Box 5027, Westport, CT 06881.

📷 YUKON TERRITORY

A huge triangular shape, the Yukon Territory occupies a vast area between British Columbia and Alaska. Like its neighbors it has coastal mountain ranges that annually collect precipitation in copious amounts. At lower elevations it falls as rain. At the higher reaches, snowfields are constantly replenished. The interior is considerably drier and has very much warmer summers and colder winters. These bitter seasons are best described by the poet, Robert Service. There are several highways through the territory, all of which are passable in the main tourist season although muddy places may mean that only four-wheel-drive vehicles can move without worry.

There are literally hundreds of small scenic waterways usually bordered by tall trees and heavy brush. Any would be worth a photo stop. Drivers on the highways may see wildlife almost anywhere, but they are characteristically fleeting glimpses. For good photo opportunities definite

stops should be made for the purpose. Kluane National Park in the south-west corner of the territory is one place. There are many privately owned lodges and camps that cater to hunters, fishermen, and photographers, but wildlife is necessarily furtive and shy where hunting is permitted.

NATIONAL PARKS

KLUANE. Kluane is located on the Alaska Highway and is easy to reach. It has the world's largest nonpolar ice fields and Canada's highest mountain. The rugged mountains, wide valleys, lakes, meadows, and tundra make spectacular scenery in any combination. An extensive network of valley glaciers radiate from the ice fields. These glaciers account for the snow and ice that covers more than half the park year-round. Vegetation ranges from forest to alpine tundra and from marshes to sand dunes.

Some of North America's finest wildlife populations inhabit Kluane National Park. Members of the largest subspecies of moose on the continent are abundant in the major valleys, and Dall sheep may be seen on Sheep Mountain and other alpine areas. Sheep Mountain is visible from the Alaska Highway, and many passersby stop, if only briefly, to search the cliffsides for our only snowwhite sheep. They are rarely disappointed. Mountain goats climb rocky slopes and cliffs in the south, and a small herd of caribou occasionally enters the park near the Duke River. Grizzlies are found throughout the park, especially in the major river valleys. Black bears prefer the forested areas. Other mammals include wolf, coyote, red fox, wolverine, arctic ground squirrel, and lynx. But these smaller creatures are more difficult to find than the larger ones. The best time to visit Kluane is from mid-June to mid-September. There are few trails and the hiking can be difficult, but often rewarding.

OTHER AREAS

OLDSQUAW LODGE. Situated on a rolling plain of alpine tundra misnamed The Barrens, Oldsquaw is a gathering place for naturalists and photographers who relish natural surroundings in a seemingly infinite wilderness. There is no hunting from the lodge, and the wildlife, from birds (over one hundred species have been tabulated) to the ground squirrels that tunnel and whistle beside the lodge, to larger species, is reasonably easy to see and photograph. The many depressions on The Barrens cup small ponds where hundreds of ducks including the vocal oldsquaw, from which the lodge gets its name, congregate in the snow-free months. In summer the sun sets for only a few hours, and its lingering low rays make lavender and blue mirrors of the little lakes set in the darkness. Moose live near the river and grizzlies push through the thick vegetation to graze and pursue the abundant ground squirrels. There is almost never a time when caribou cannot be seen through the lodge's spotting scope. From time to time packs of wolves pass through. See everything guided by Oldsquaw's owner and proprietor, Sam Miller. Sam is a biologist with immense knowledge of the area and its denizens. Go on day hikes, travel by canoe, backpack to a cabin in the Selkirk Mountains, ride a horse-drawn wagon. For more information write: Sam Miller, Oldsquaw Lodge, Bag Service 2700 (B), Whitehorse, YT Y1A 4K8, Canada.

◉ ALASKA

No Canadian territory or province, no other state, and probably no place on earth, if one includes the individual fishes and birds, can match Alaska for sheer mass of wildlife. Add the lure of remoteness and legend to this magnificent scenery, and you have the greatest potential for outdoor photography anywhere on earth. The main drawbacks are well known: Alaska's great distance from the main population centers in the lower forty-eight (known as *Outside* to Alaskans), the notoriously high prices of nearly everything, and the weather that, although interspersed with pleasant days, is generally wretched and gets worse.

The most intrepid photographer could never know all of what its native peoples called The Great Land. The best any of us can do is explore it in pieces: the seabird rookeries with millions of nesters, the rivers of ice, the tundra that is measured in hundreds of square miles and becomes a tapestry of red and gold in the fall, the pods of whales, the schools of scarlet salmon, and the numbers of large mammals rivaling those on the plains of East Africa.

Alaska is not easy to explore. There are four ways to arrive: by air, by road, by ferry (the Alaska Marine Highway mainly), or by tour ship. Good planning is essential, but the avalanche of available information is overwhelming. The best publication is THE MILEPOST®. It incorporates almost every piece of usable information for anyone planning a trip to Alaska. THE MILEPOST® is updated annually and is sold in bookshops or is available from Alaska Northwest Publishing Co., 130 Second Ave. South, Edmonds, WA 98020 for $14.95 plus $1.00 postage.

The first (and so far only) luxury vessel to accommodate vehicles and passengers is the *Stardancer,* which began affordable, comfortable service from Vancouver, British Columbia, in June 1985. The cruise ship sails the Inside Passage to Haines and Skagway, Alaska. For more information write: Sundance Cruises, 520 Pike St., Suite 2200, Seattle, WA 98101 or telephone 800/222-5505.

NATIONAL PARKS

DENALI. Until recent years, Denali was known as Mount McKinley National Park, a name now reserved for the highest massif in North America that dominates the park. Denali is located in central Alaska and is the second largest park in the United States (after Yellowstone). The happy combination of magnificent scenery and large concentrations of the most noble wildlife on our continent make this the most likely place in the state for the photographer to use more film than he had planned.

It is also the only place in the national park system where you can film barren-ground caribou and Dall sheep. The snowy sheep stay high on grassy slopes in the summer, but it is relatively simple to locate them from the single park road and then carefully climb to where they graze. The sheep feel secure at heights and are unlikely to flee with the proper, calm

approach. Caribou are scattered in the summer, but as the season progresses they come together in small, then larger groups, preparatory to a large migration. The most likely places to find grizzly bears are at Sable Pass and Toklat River. Alaska moose, larger than the Rocky Mountain variety, begin to gather at Igloo Flats in August, and the bulls spar with limber trees or one another as the seasonal rut approaches. Walrus are seen more and more often in recent years and promise to become another park attraction as time passes. Red foxes, arctic ground squirrels, pikas, ptarmigan, and hoary marmots are also reasonably abundant in Denali. Altogether it is unusual to spend a day in Denali and not see something wonderful.

It may snow at any time, but the first appreciable amount usually falls by early September. Overcast days are common, and those who spend only a few days here may never see Mount McKinley's peak as it lies hidden behind low clouds. The best views of the revealed 20,320-foot summit are from Wonder Lake at the far end of the ninety-mile-long park road.

All transportation on the road after the visitor reaches his camping site or other accommodation is by free shuttle bus. Buses run frequently and passengers may get on and off at any point. The bus drivers have a high vantage point and can spot wildlife others might miss. In addition, the higher bus windows offer a better view than that from low-slung private cars. There are also buses run by private companies with either whole or half-day tours, and these are especially recommended. Hiking in the park is permitted in most areas (some areas are closed to avoid dangerous bear encounters), but there are few trails, and the going is difficult.

GLACIER BAY. When the Alaska Lands Bill passed Congress in 1980, 57,000 remote acres along the Gulf of Alaska coast, from Cape Fairweather north to the Alsek River, were added to the park. Even before this addition, Glacier Bay was famous for its tidewater glaciers, including the Grand Pacific Glacier that once filled the bay. It has retreated forty miles since first seen by Captain Vancouver in 1794. The bay is surrounded by a deep green, moss and lichen-covered rain forest, where mushrooms in seemingly unnatural colors grow. The islands, cliffs, and rocky shorelines teem with birds—kittiwakes, puffins, cormorants—and the watercourses hold mergansers, scoters, and other sea ducks. Humpback and killer whales cruise the bay in summer, and harbor seals lounge on ice slabs in front of Muir Glacier. Black and brown bears are occasionally seen and moose and Sitka black-tailed deer lurk in the rain forest.

There are several ways to photograph Glacier Bay: by hiking (least productive), on day or overnight boat cruises, from large cruise ships, or by way of a combination seaplane/yacht journey. In any case, the only way to get to the park is to fly to Gustavus or arrive by sea. There are no roads here.

The huge scale of Glacier Bay necessitates the use of various lenses, each of a different focal length. The short lens gives a feeling for the overall look of sea with floating ice slabs, the glaciers in the medium distance, and the deep forests surrounding all. Medium telephoto lenses are best for creatures with their habitat, and long lenses for frame-filling shots of seals on ice. Use closeup lenses for intimate views of the wonderful array of colorful mushrooms and other fungi in the rain forests. Be sure to carry along waterproof containers for the camera equipment, because it can rain at any time.

It is difficult to get good photographs of dark objects (such as a seal) on a light background (snow or ice). The rule of thumb is to expose for the dark subject. This will make the background nearly white, but otherwise, the subject will be only a dark shadow on properly exposed snow or ice.

Taking pictures early and late in the day and when the sun lights the scene from the side, rather than straight on, helps, as does filling the frame with the subject.

Most visitors go to Glacier Bay with a tour arranged beforehand. Others come on their own, but either way, arrangements must be made well in advance of the trip. Reservations for boat tours can be made in the park.

There is a campground at Bartlett Cove (near the lodge where most visitors stay) that is open from May to September, the main months for visiting Glacier Bay. Wilderness camping is also available throughout the park. Moorage, fuel, and supplies are available for those who arrive in their own craft.

KATMAI. After the McNeil River Sanctuary (see State Parks section), Katmai is the best place in Alaska to photograph brown bears. A large number live in the hills in the north part of the park. During the sockeye salmon runs, which begin in early July, the bears can often be seen in the Naknek River drainage and near Brooks Falls, where a viewing platform is situated. Although the bruins and visitors share the same damp footpaths through tall grasses, there has never been a fatal bear incident. Wolves, moose, and caribou in addition to sea mammals and smaller life can also be seen at Katmai.

Mount Katmai exploded with tremendous force in 1912 and the episode ended with a landscape of smoking fumaroles, which was promptly named the Valley of Ten Thousand Smokes. Volcanic activity has long since ceased, and the area is now covered by three hundred feet of pale ash. A scenic feature is a shallow jade green lake in the crater of the volcano called Novarupta where a huge volcanic plug protrudes. The southeast section, not often visited, is along the wild Shelikof Strait with its bays, fjords, and lagoons.

The best way to reach Katmai, a favorite destination of fishermen, is by scheduled air charters to King Salmon on the park's edge, or by air taxi. There are no roads. The photographer should cautiously hike the trails for best views of the bears and take a van tour to the Valley of Ten Thousand Smokes. Backpackers and vigorous photographers relish the more remote areas in the valley and beside the sea.

KENAI FIORDS. A new (1980) treasure in our national park system, Kenai Fiords is a breathtaking mountain-fjord system on the southeast side of the Kenai Peninsula. Harding Icefield, a seven-hundred-square-mile mass, caps the park. Its edges splinter into tidewater glaciers. Many consider the scenery here better than that at Glacier Bay. Certainly the wildlife occurs in greater numbers and is easier to see and photograph.

Boats run by the Kenai Fiords Tour Inc., Box 881, Seward, AK 99664, provide the best way to see the spectacle. Embark on any of their craft and expect a day you will never forget.

The glaciers, one after another, creep and grind down rocky clefts to the dark sea. One, Holgate, presents a massive ice wall with calving pieces creating large swells in the otherwise (in summer) calm waters of Aialik Bay. Sea otters swim close to the bulkheads, and mountain goats walk impossible cliffs. Harbor seals relax on slabs of floating ice or gather on Cheval Island. Steller sea lions haul out on rocky islands. The deep water allows boats to get very close to the islands. Killer whales, minke whales, and Dall porpoises sometimes loiter nearby. The bird life is as rich as anywhere in Alaska; easiest to photograph are the nesting birds including both the tufted and horned puffins. Unfortunately the skies are often overcast, so bring fast film and the fastest lens possible. The offshore islands are in the Alaska Maritime Wildlife Refuge.

The gyrfalcon (opposite), an Arctic raptor, is not uncommon in Yukon Territory. Look for the birds around siksik or Arctic ground squirrel colonies, where they might also become accustomed to human presence.

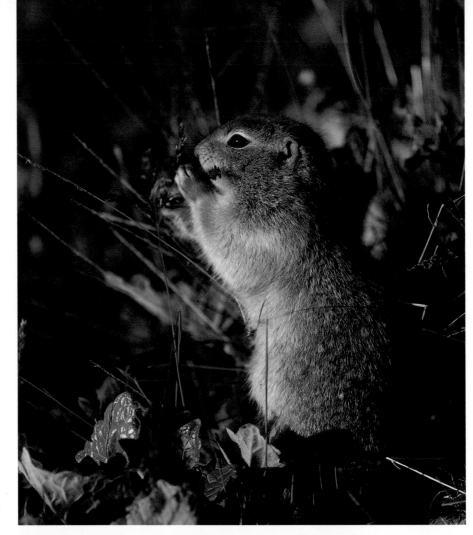

Arctic ground squirrels of the Yukon have only a brief season in which to feed and grow fat before winter hibernation. So they are busy and always appealing photography subjects. A grizzly bear dug this one from its den soon after the picture was taken.

Denali National Park is one rare place where a photographer might be able to see gray wolves in his viewfinder. These young males are play-fighting on a snowbank.

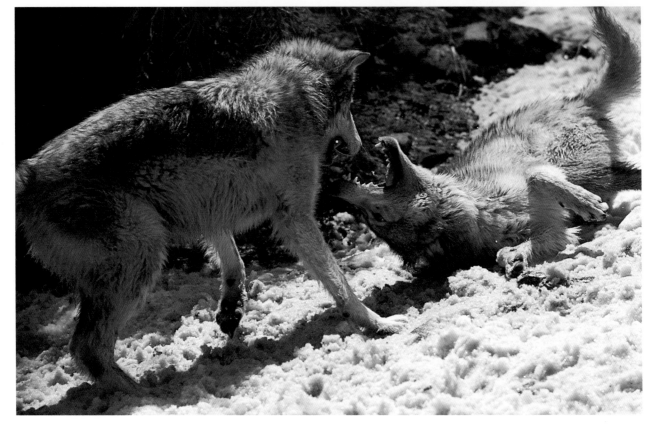

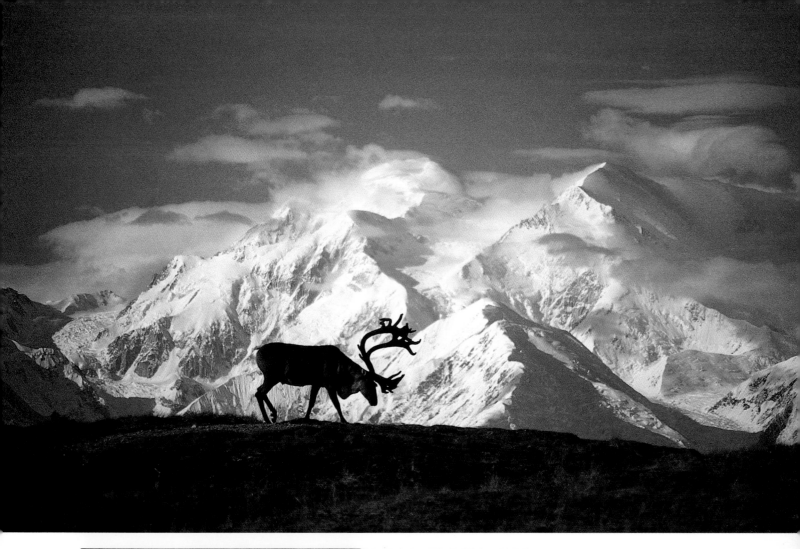

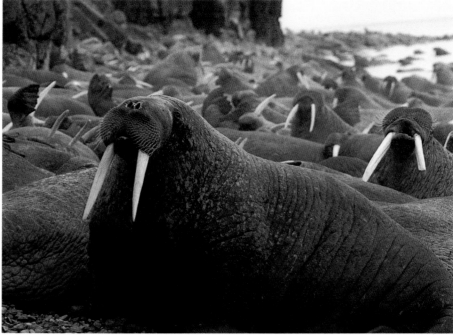

A bull caribou crosses a ridge and is silhouetted against glaciers of the highest mountain in North America, in Denali National Park. The photograph was shot one early morning in late August.

Perhaps the best place in all of the world to find walrus in the summer is on Round Island, Alaska. About eight hundred bulls haul out here to spend the season. A permit from the Alaska Fish and Game Department is necessary to visit the island, and a photographer must be entirely self-sufficient for whatever length of his stay.

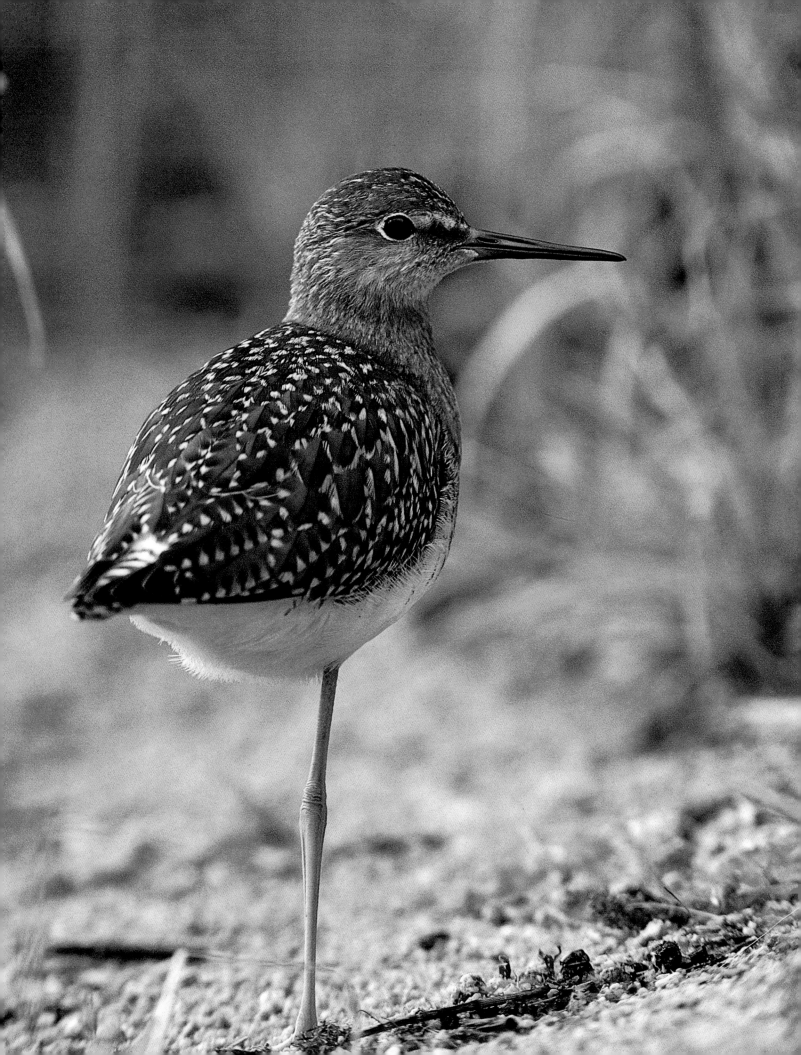

Hiking the backcountry is not advised (although permitted) as the understory is dense, and the terrain is steep.

Kenai Fiords Park also protects Exit Glacier, another extension of the Harding Icefield. It is an ice mass of another sort that can be reached by a short auto drive from Seward plus a moderate, level hike. The crevasses are easy to see and photograph. Look for iceworms on the surface of the glacier and in nearby meltwater. They are dark and about an inch long. They make interesting, if not beautiful, photographs. Watch for moose in the nearby cottonwoods and spruce.

Seward is a rare place in Alaska. It can be reached by auto, plane, or boat. An especially pleasant way is by ferry from Valdez. At this writing, the boat still stops for a long look at Columbia Glacier where the frigid wind off the ice flows over the boat deck, and harbor seals seem comfortable on floating chunks of ice. Near Seward, at Bainbridge Glacier, thousands of seabirds live and nest on rock cliffs. A blast from the ship's whistle startles the birds into a pale flickering mass against the black cliffs. For more information see The Alaska Marine Highway System at the end of this section.

LAKE CLARK. Lake Clark is a startlingly beautiful area, and one conservationists were particularly anxious to see preserved. It reaches from Cook Inlet to the top of Mount Redoubt volcano. The wildlife there includes Alaska's favorites, each in its own niche. Black bears and moose live in the green valleys, caribou and brown bears roam the tundra, and at the upper elevations, Dall sheep graze in green meadows. As in all of coastal Alaska, summers are cool and often cloudy inland. Shoreline areas are wet. The farther from the sea, the drier and sunnier the climate. The interior of the park can be reached by air; boats can land on the sea side. Those who do not bring camping equipment stay in privately owned lodges within the park.

NATIONAL FORESTS

CHUGACH (Portage Glacier Recreational Area). Only fifty miles from Anchorage, Portage Glacier is one of the most visited attractions in Alaska, and that is not surprising. Easy to reach by good road, Portage is an attractive sight with Portage Lake in the foreground. Although the glacier advances fifteen inches per day, the rate of melting is much greater and counteracts the advance with a dramatic pullback. The large blue lake with its floating icebergs makes a more pleasing photograph than the glacier itself, which is quite distant. The surrounding forest shows the effects of the vicious winds that may whip through. Shrubbery facing the glacier is wind pruned and grows densely. The trees have had all their windward branches broken off. The wildlife of the valley is seldom seen during the tourist season, but it includes bears, goats, and moose. A better subject for the photographer is Byron Glacier, a rocky level walk from the road's end. Dwarf fireweed and twisting rivulets of meltwater make an attractive foreground for the glacier.

NATIONAL WILDLIFE REFUGES

KODIAK. At the height of summer, in July and August, huge Kodiak brown bears congregate on the refuge in the southwest part of the island, where salmon enter the streams to spawn and die. During this time the fish constitute almost the entire diet of the bruins. Conveniently for the bears, when the fish run is over, the berry season begins. A prudent photographer can

The lesser yellowlegs (opposite) was photographed standing on one leg a short distance from our van, which was parked in a lakeside campground on the Alaskan Highway. We have found many creatures to photograph around public camping areas.

see it all. The fish scraps and uneaten berries attract other creatures: eagles, gulls, red foxes, and otters. Introduced black-tailed deer and Roosevelt elk can be seen, too. Also on the island is the world's largest harbor seal rookery and one of the largest sea lion colonies in Alaska.

The most convenient way to reach Kodiak is by air. Private charters (air or boat) are needed to reach the best places on the island or the offshore islands. Only a short distance away is Afognak Island (described on p. 115).

NUNIVAK. Nunivak is an island twenty miles into the Bering Sea from Bethel. The refuge was established to protect the vanishing musk-oxen. The successful outcome of the project has allowed surplus animals to be transplanted to areas where they once lived. A good way to find the musk-oxen is to hire a boat at Mekoryuk, the island's only village, and sail along the shore watching for the creatures in the tall grass. Do not expect them to obligingly form a circle; they have become elusive with the large amount of human intrusion and countless studies that have been made on them. In summer there are large seabird colonies on the cliff sides. You can reach Nunivak by air. Facilities are extremely limited.

STATE PARKS

CHILKAT BALD EAGLE PRESERVE. The largest concentration of bald eagles in the world occurs between October and the end of December along the Chilkat River northwest of Haines near the tiny village of Klukwan. At this time there is a late run of spawning chum (dog) salmon; a bonanza for the birds since all other migrations have by now ended. Most photographs of bald eagles on riverbeds, eating salmon, and in snowy trees were taken here. November is the time to see the largest number. There is easy viewing from the highway. Long lenses are necessary, and the weather is generally obnoxious: wet, cloudy, and cold. Haines can be reached by almost any means; private transportation to the eagle area is desirable. There are campgrounds, camper parks, and more luxurious accommodations in Haines.

KACHEMAK BAY. See the Alaska Marine Highway System section for Homer.

McNEIL RIVER STATE GAME SANCTUARY. The best and safest place in Alaska to photograph the Alaska brown bears is here at the root of the Alaska Peninsula. Each summer between July and mid-August chum salmon migrate up the river and pause at the falls where a large contingent of bears (and ten photographers) await them. Large and small bears, boars, and sows with cubs vie for the best fishing beats and exhibit ingenious methods of catching the hapless fish. The Alaska Department of Fish and Game holds a drawing for the necessary permits each May. A state employee escorts the visitors from the primitive campground to the falls daily. The campground is open to anyone; the falls area (during the salmon run) is not. Charter aircraft from Homer is the best way (albeit expensive) to reach the sanctuary.

PRIBILOF ISLANDS ALASKA MARITIME NATIONAL WILDLIFE REFUGE. Saint Paul Island, one of the Pribilofs, offers one of the finest opportunities to see and photograph the incredible 211 species of birds that nest here. Northern fulmars, cormorants, kittiwakes, and many others are relatively easy to see as they group on the cliff faces like residents of a popular condo.

Arctic foxes (blue phase) stalk the area alert for an easy meal. Five hundred reindeer wander at will. In addition to the birds about 80 percent of the world's northern fur seal population (approximately one million) hauls out on the rocky shores in May to give birth to adorable pups and then enthusiastically breed again. They can be seen and photographed from two blinds. Bulls guard harems of cows, driving off other intruding bulls in ferocious combat. The scene of furious activity continues noisily and with a tremendous odor until October when the last of the seals have again taken to the waters of the north Pacific. Poor weather hampers photography (heavy fog is frequent from May to August), but breaks do occur. Commercial tour companies bring tourists here or one can come on one's own from Anchorage.

WALRUS ISLAND STATE GAME SANCTUARY. The very best photographs of masses of bull walruses were taken on Round Island, one of the Walrus Islands. A popular place for serious rugged photographers, the island also hosts Steller sea lions, red foxes, and masses of seabirds. All are photographable when the weather cooperates. Access is difficult and expensive, and permits are required from the Alaska Department of Fish and Game in Dillingham. High winds and large amounts of precipitation are to be expected.

OTHER AREAS

AFOGNAK ISLAND. A short distance from Kodiak Island, tiny Afognak's northwest portion is part of the Kodiak Refuge. But wildlife can be seen on any part of the land mass. This lovely forested oasis is a wonderful destination for any naturalist or wildlife photographer to concentrate his/her time, film, and money. Brown bears fish for salmon in the shallow streams, introduced Roosevelt elk and Sitka black-tailed deer roam. The confiding sea otters that patrol the shorelines can be photographed from a boat at close range as can humpback whales. The easiest way to visit Afognak is to fly a chartered plane from Kodiak Island and stay at comfortable Afognak Wilderness Lodge. With this as a base, the photographer is close to all camera subjects and guides will point out the creatures as well as take him to see sea lions and puffin rookeries. For information write: Afognak Wilderness Lodge, Seal Bay, AK 99697 or telephone 907/486-6442.

THE ALASKA MARINE HIGHWAY SYSTEM. A fleet of nine ferries connecting Seattle, Washington, or Prince Rupert, British Columbia, to many of the coastal towns of Alaska is the best way for many, if not most visitors to reach The Great Land. Some states have railroads; Alaska has the ferry system. Not a tour/cruise venture by any means, the ferries are instead a unique transportation network. The vessels choose a route in the sheltered Inside Passage passing close to shore at many points to give passengers a good view of waterfalls, glaciers, icebergs, and fjords. Fishing boats, whales, and porpoises share the waters; bald eagles perch on dark green conifers and bears wander the beaches. Fares for passengers who travel without cabins (often sleeping in tents erected on the aft deck) are inexpensive. For an Alaska visit of any length, having one's own vehicle is the cheapest and most practical way to see Alaska.

For ferry information write: Alaska State Ferry, Pouch R, Juneau, AK 99811 or telephone 907/465-3941. December is not too early to make plans for the following summer.

Below are some of the ports of call of greater interest to photographers.

HAINES. The best beginning point for highway links to inland Alaska and the closest point to the Eagle Sanctuary.

SITKA. One of the earliest Russian settlements lies beneath Mount Edgecumbe, "Mount Fuji of the Western Hemisphere." The historic park in the huge hemlocks displays Tlingit and Haida totem poles.

KETCHIKAN. Known as the rainiest town in the United States, Ketchikan has the largest collection of totem poles in the world, many visible from the deck of the approaching ferry. Salmon can be seen migrating upstream in waterways that bisect the town.

JUNEAU. Mendenhall Glacier, at the north end of the capital city, is the most accessible glacier in Alaska. See mountain goats on Bullard Mountain from September to May. Red salmon spawn in Steep Creek near the visitor center from July through August. Leave Juneau for the twenty-eight-mile flight to Pack Creek on Admiralty Island where brown bears fish for salmon. From highway pullouts along Juneau's coast look for geese, ducks, and shorebirds in the Mendenhall Wetlands State Game Refuge. Flights over the Juneau Icefield help you appreciate its size.

HOMER. Located on the tip of the Kenai Peninsula, Homer is about as far as one can drive via interconnected roads on the North American continent. It is also on Kachemak Bay where a photographer can find countless scenes and creatures to photograph. Take a boat tour to the seabird rookery on Gull Island, where nesting birds, including puffins, can be photographed. In Peterson Bay watch for harbor porpoises, harbor seals, and in August, small groups of killer whales. The many species of wildflowers on shore include the sundew, a carnivorous plant that lures insects to its sticky petals. The underwater life is abundant and best seen from the glass-viewing window on the floor of one of the tourist vessels. Kachemak Bay State Park is a good stop and is located near Halibut Cove where houses on stilts line the shore.

SEWARD. See Kenai Fiords National Park from Seward. The ferry from Valdez to Seward is an alternative to the long drive. It stops at the face of the Columbia Glacier for good views of the glacial activity and harbor seals lazing on ice slabs.

VALDEZ. Famous as the terminal of the Alaska oil pipeline, Valdez is also one of the most beautiful small towns in the state. Worthington Glacier is a drive-up glacier that can be photographed and even walked on. Spawning salmon can be filmed from a platform at Crooked Creek and also from the road to the terminal. Best photo opportunities are from Stan Stephens Charter boats, one of which will be suitable for any purpose from day trips to more adventurous journeys of longer duration. The most popular excursion is to Columbia Glacier to see the mechanics of a tidewater glacier and the wildlife of the sea. Whales, sea lions, and sea otters may feed, travel, and play near the boat. For more information write: Stan Stephens Charters, Box 1297, Valdez, AK 99686.

Staggering published rates for motel rooms in Valdez are over $100 per night. But camping vehicles and parks for them are everywhere, and the attractive (although primitive) Valdez Glacier Campground is absolutely free. This is only one of the many free (or nearly free) campgrounds maintained by the towns and cities in Alaska.

Further Reading

Bauer, Erwin A. *Bear in Their World*. New York: Outdoor Life Books, 1985.

———. *Deer in Their World*. New York: Outdoor Life Books, 1983.

———. *Horned and Antlered Animals in Their World*. New York: Outdoor Life Books, 1986.

Bauer, Erwin and Peggy. *Wildlife Adventures with a Camera*. New York: Harry N. Abrams, 1984.

Burt, William H. and Richard Grossenheider. *A Field Guide to the Mammals*. Boston: Houghton Mifflin, 1952.

Dalrymple, Byron. *North American Big Game Animals*. New York: Outdoor life Books, 1985.

Grimm, Tom. *The Basic Book of Photography*. New York: New American Library, 1985.

Harrison, Hal H. *A Field Guide to Bird Nests*. Boston: Houghton Mifflin, 1979.

National Geographic Society. *Field Guide to the Birds of North America*. Washington, D.C., 1983.

Peterson, Roger T. *A Field Guide to the Western Birds*. Boston: Houghton Mifflin, 1965.

Reader's Digest. *North American Wildlife*. New York, 1982. (Author's note: This is the finest guide to birds, animals, reptiles, trees, small plants, seashore life, and fish available in one volume today.)

Rue, Leonard Lee III. *How I Photograph Wildlife and Nature*. New York: W.W. Norton, 1984.

Shaw, John. *The Nature Photographer's Complete Guide to Professional Field Techniques*. New York: Amphoto, 1984.

Stebbins, Robert C. *A Field Guide to Western Amphibians and Reptiles*. Boston: Houghton Mifflin, 1966.

Index

Selected Books
from Pacific Search Press